CREATING **WATERCOLOR** LANDSCAPES USING PHOTOGRAPHS

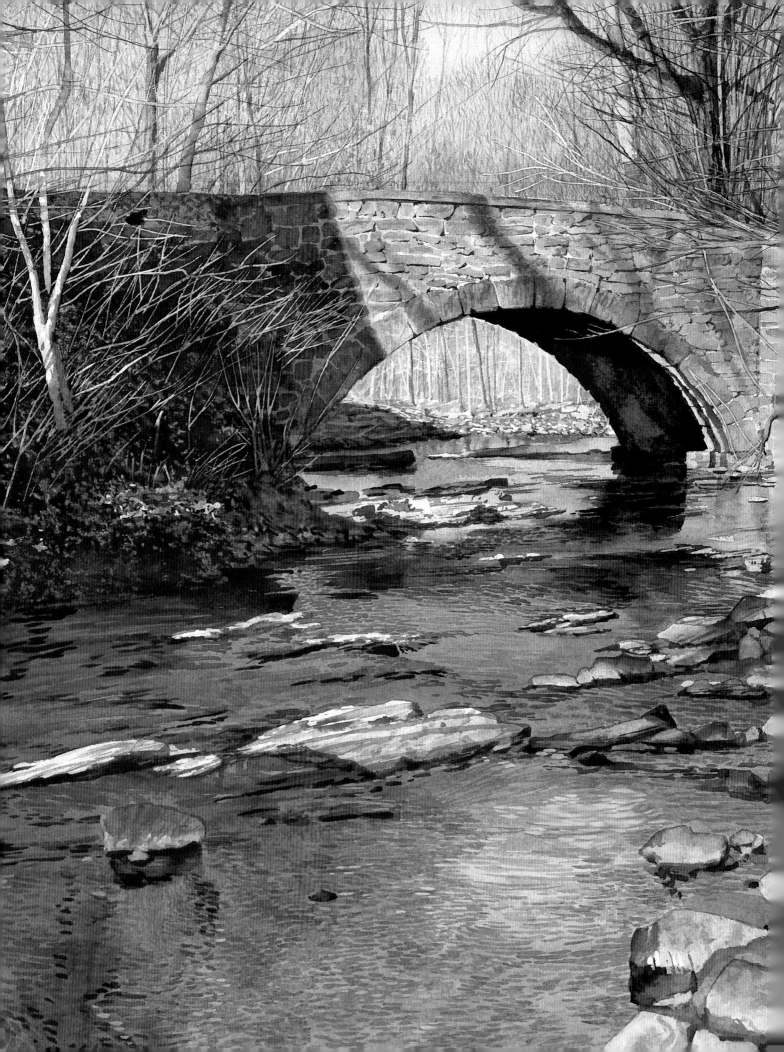

CREATING WATERCOLOR LANDSCAPES USING PHOTOGRAPHS

Donald W. Patterson

NORTH LIGHT BOOKS
CINCINNATI, OHIO
www.nlbooks.com

About the Author

Don Patterson is a nationally recognized watercolorist. He has exhibited in museums and galleries across the U.S., Japan and Canada and is a consistent award winner in regional, national and international juried exhibitions.

He is a graduate of the Philadelphia Museum School of Art, now called the University of the Arts. Since serving as a Training Aids artist in the U.S. Navy during the Korean War, he has freelanced as an illustrator/graphic arts designer. He was Product Design Manager for the Franklin Mint from 1977 to 1985. Since then his primary focus has been watercolor.

Patterson is a member of the American Watercolor Society, the National Watercolor Society, Allied Artists of America, Audubon Artists, Inc., the Pennsylvania Watercolor Society, and is an Honorary Life Member of the Philadelphia Water Color Society. He is listed in the Millennium Edition of *Who's Who in America*.

Patterson has been featured in *American Artist* magazine, *The Artist's Magazine*, *Watercolor Magic*, *U.S. Art* magazine, and on PBS's *Outdoor Pennsylvania*. In 1990, he was a winner in the *American Artist* magazine competition "Preserving Our Natural Resources."

Patterson's work was chosen for *Splash 2*, *Splash 4*, *Splash 5* and *Painting the Many Moods of Light* published by North Light Books, and appeared in *The Best of Watercolor 2*, *Painting Light and Shadow* and *Painting Texture* published by Rockport Publishers.

04 03 02 01 00 5 4 3 2 1

Library of Congress Cataloging in Publication Data

Patterson, Donald W.
 Creating watercolor landscapes using photographs / by Donald W. Patterson.
 p. cm.
 Includes index.
 ISBN 0-89134-973-1 (hrdcvr.)
 1. Watercolor painting--Technique. 2. Landscape painting--Technique. 3. Painting from photographs--Technique. I. Title.
ND2422 .P38 2000 99-053782
751.42'2436—dc21 CIP

Edited by Jennifer Lepore
Production edited by Jolie Lamping
Cover designed by Amber Traven
Interior designed by Brian Roeth
Production coordinated by John Peavler
Title page art: *Copper Creek,* 18" × 26" (46cm × 66cm), Private collection, see page 21
Cover art: *Country Road,* 13" × 21" (33cm × 53cm), Collection of the artist, see pages 66-71

Acknowledgments

So many people have helped and influenced my artistic career during the course of my life, too many to list in this allotted space, but I would be remiss if I didn't mention some standouts from my past and a few from the present who helped me directly with this book.

My art career started with the Philadelphia Museum School of Art, now called the University of the Arts. It was there I was blessed with so many outstanding and dedicated teachers for whom I have wonderful memories, undying gratitude and respect. In drawing class, Karl Sherman and Fred de P. Rothermel; in watercolor painting, Benjamin Eisenstat, W. Emerton Heitland and Albert Gold.

At North Light Books, many thanks to Rachel Wolf for providing me the opportunity to write this book and my editor Jennifer Lepore, without whom I would have been adrift.

Many thanks to Bob Coldwell, photographer extraordinaire, for his technical input and for the many images that grace these pages that were reproduced from his transparencies; my good friend and fellow artist Joe Frassetta for helping me on field trips necessary to the completion of this book; Judy Antonelli, a dear friend and fellow artist, whose disarming smile and demeanor made us both welcome onto private properties that have provided me with a wealth of what otherwise would have been inaccessible subject matter; to Vicki Parry of Buckingham Photo, for saving the day more than once and showing me how to operate my new camera; and last but not least, Noreen Chernouskas, owner of Buckingham Impressions, and her staff for always giving me much needed fast service and allowing me free access to the copy machines.

Dedication

To my wife, Marjorie, and our children, Donald Jr., Paul and Steven

Table of Contents

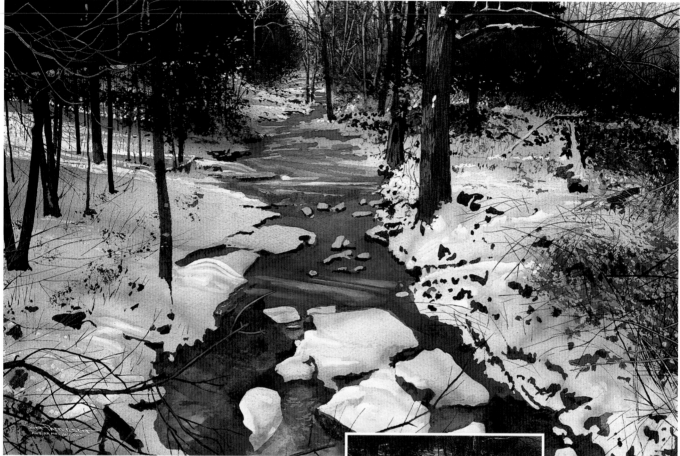

Winter Brook
13" x 20" (33cm x 51cm)
Collection of the artist

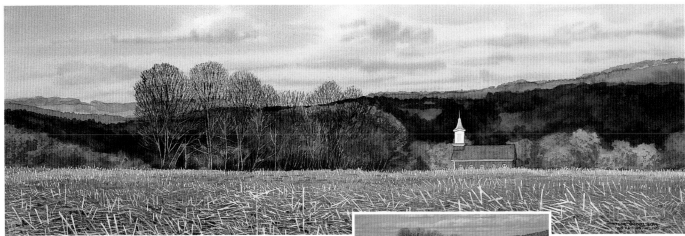

View From Frogtown Road
9" x 27" (23cm x 69cm)
Private collection

Capturing Moments—The Poetry in Art

I want to quote in part Emily Dickinson: "If I read a book and it makes my body so cold, no fire can ever warm me, I know that is poetry. If I feel a powerful wave of the ocean striking the beach, I know that is poetry. If I see a pink light move across the fields of white snow and touch the side of a red barn, I know that is poetry. If I see the lacy branch of winter trees, I know that is also poetry."

The viewers of Don Patterson's paintings must pause and pause again and see for themselves whence the "moment" is caught. At the crowing of the proud rooster; the movement of the tall sea grass in the warm wind; the seagulls that stand like sentries on the gray beach. The sight and sound of it all, he gives to you. I know that is his poetry.

The titles of his paintings also tell us about Don Patterson's view into the human world. We can walk away with a smile and experience his candor that identifies the subject in some dilemma of human experience. *Udderly Cool*, *The Welcome Committee*, *Peeping Tom*—his work reflects the background of his view of life, once again the many paradoxes of human nature.

The road of creative intuition is exacting and alone. Don Patterson is the road of technical and aesthetic vision of the world of nature in all its chaos and order, and he demands that of himself. The means to the end is the matter—the "true artist's" intent is a personal vision of human communication to which we can all relate. This is Don Patterson's quest to achieve. He gives us that chance to pause and acknowledge the gifts of nature. Only the truth, we are told, makes us free. Don's work is himself.

I shall always remember the sheep in the amber valley and the sound of the bells moving across the pasture, the great tree stretching its dark limbs for the wooly guests to arrive. I know that is your poetry, Don, you painted it.

Isa Barnett

Isa Barnett began his career in art at Fleisher Art Memorial and the Philadelphia Museum College of Art, Pennsylvania. After an admirable service in World War II, Barnett combined teaching and freelance work, creating illustrations for the *Saturday Evening Post*, *Argosy*, *Life*, *American Heritage* and *Reader's Digest*. Included among his many other achievements are a body of work resulting from his service as a U.S. Navy correspondent/artist in Vietnam, and a series of designs for the Franklin Mint. Barnett can now be found much of the time at his Santa Fe studio, painting the Southwest.

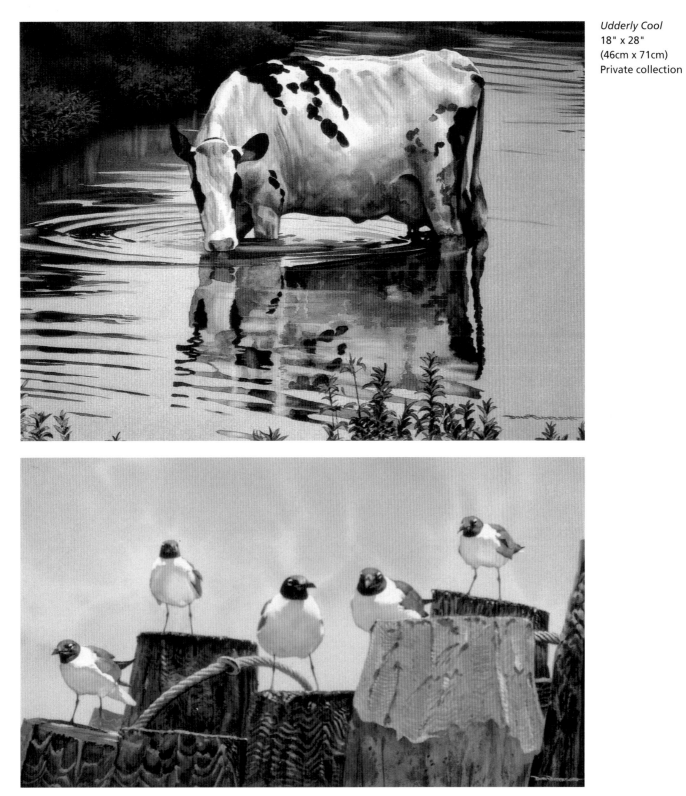

The Welcome Committee
15" x 28" (38cm x 71cm)
Collection of Marsha Brason

Working From Photographs—An Artist's Prerogative

This book is about how to use the camera and other photomechanical aids to reach your artistic goals in painting a landscape. I have traveled a very long and winding road on my journey to discover who I am in this wonderful and always challenging world of art. During this journey I have listened to, observed and absorbed a lifetime of information, and all of it is useful in some way, but out of all this, one thing stands above everything else: In art you must discover your own truth, and when finding this truth, you and your methods are validated in whatever it takes to achieve your goals.

I am telling you all this because I know there is a segment of artists who will tell you that if you use photographic devices in the course of your work, you are a fraud or at best cheating. Nothing could be further from the truth (there is that word *truth* again). The fact of the matter is I personally do not know any artists who do not use a camera or some photomechanical device in some way to aid them with their art. I also know there are many artists who use cameras and other photomechanical devices and simply don't admit it. This group is the only one that troubles me. I hope in reading this book you will learn and understand the legitimacy of using any tool in the creation of your art if you are properly informed and trained in its usage. You will be in the company of such greats as Vermeer, Degas, Eakins, Manet and Toulouse-Lautrec, to name a few.

As you read this book there is one salient point I will make more than once: No mechanical device is creative. All the creativity comes from the artist. It is you, the artist, who must select, compose and edit your subject matter. All concepts and ideas flow from you, and no mechanical device will ever be a worthy substitute for any artist's talent and hard-earned skills.

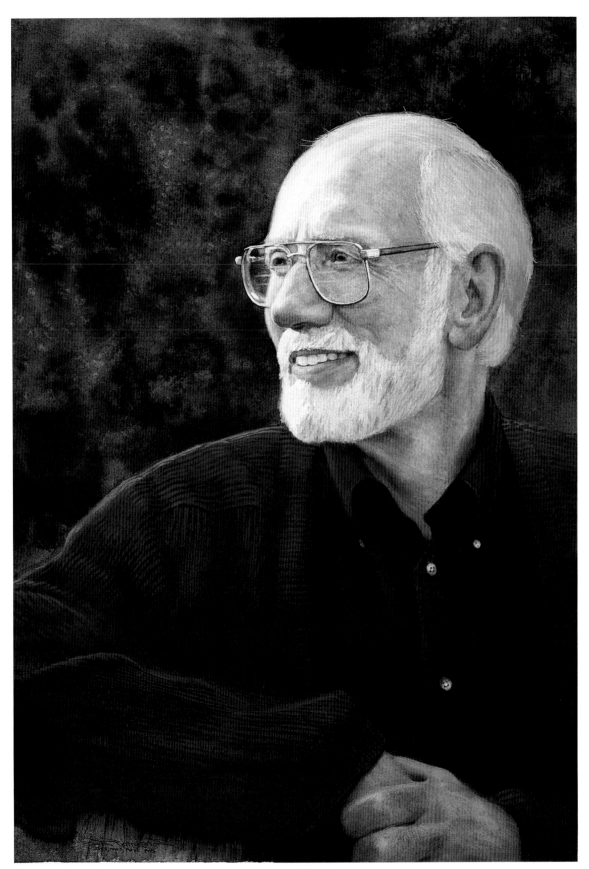

Self Portrait
20" x 15½" (51cm x 39cm)
Collection of the artist

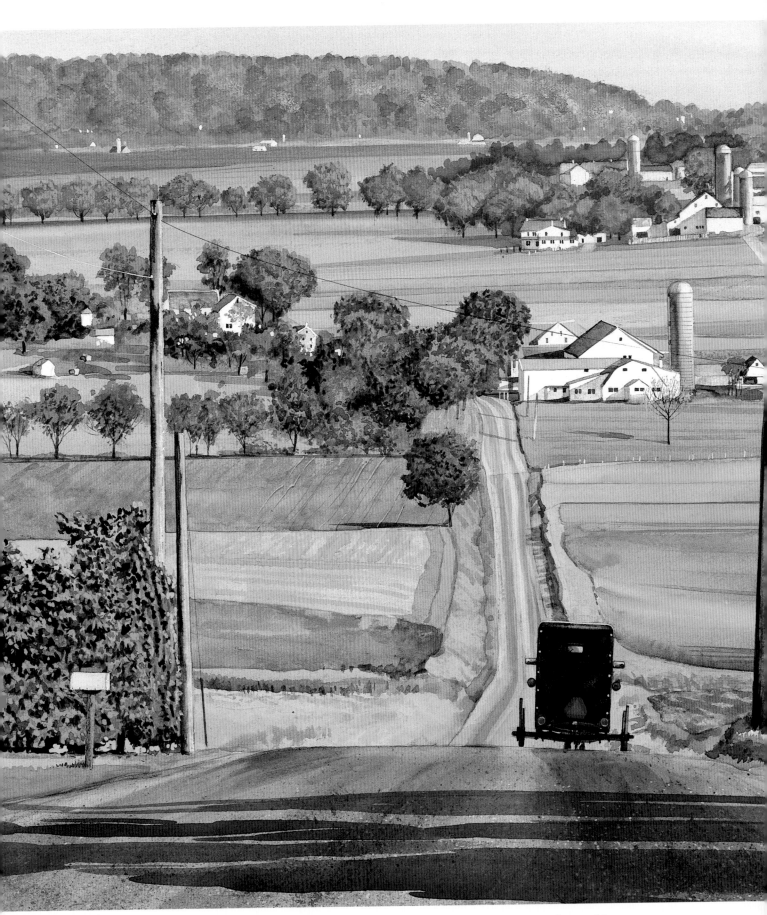

This is a quintessential view of the Lancaster County, Pennsylvania, countryside. I was on my bicycle when this scene first came into view—what a great ride!

Lancaster County, PA
16¼" x 24½" (41cm x 62cm)
Private collection

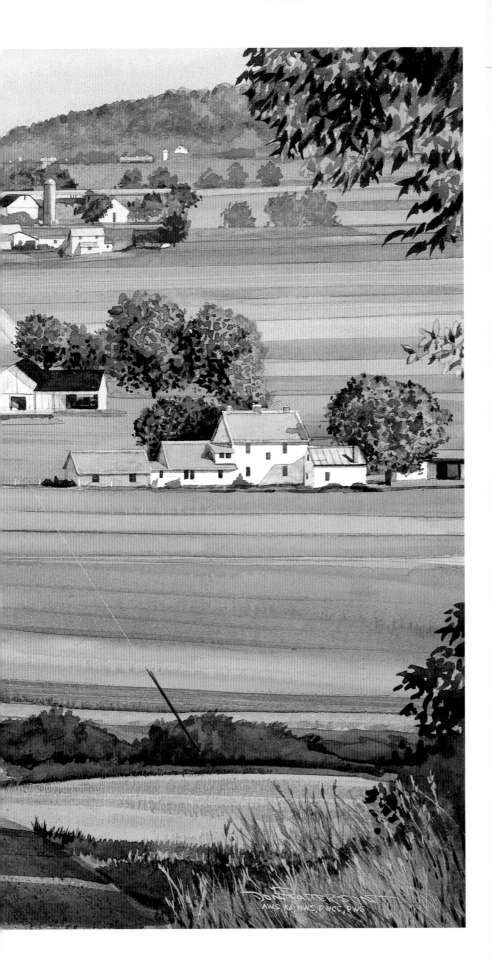

Looking Through the Lens

Cameras are indispensable in the creation of my art. They are just as much a part of the creative process as the brushes, paint and paper. The creative process starts the moment I look through the lens. This is an emotionally charged moment, because this is the beginning of another painting adventure.

Only Photograph What Excites You

Discovering subjects you want to paint is the most exciting part of creating a painting. I always get an emotional high when I record my subjects with a camera. Over the years I have learned never to take pictures of anything without a feeling of heightened interest and compelling desire to paint the subject. Creating a painting is hard work, and you need that initial excitement to sustain your interest throughout the entire painting process.

Compose With Your Camera
A perfect example of a subject that requires a wide-angle zoom lens. It took only seconds to compose this scene through the lens while standing in the middle of the road—not the ideal vantage point for plein air painting.

Camera Equipment

When purchasing camera equipment, try to put the emphasis on need. There is such an array of available equipment that it is easy, if you have the resources, to go overboard with "stuff." Remember you are a painter, not a photographer. With today's camera technology, you can achieve marvelous results with a minimum of basic equipment.

Camera Body

An SLR 35mm camera (single-lens-reflex or through-the-lens metering camera) is, in my opinion, the best camera for a landscape artist, because it allows you to look directly through the lens and see exactly what you are going to get. It also has a built-in light metering system, which facilitates proper exposures.

Having two camera bodies is not necessary, but it makes life a lot simpler in the field. Switching lenses can be a nuisance under certain conditions, particularly if you are shooting a moving subject. In this scenario you could miss "the shot" in the extra time it takes to switch a lens.

Another way to ward against missing a shot is to use a fully automatic camera. The autofocus and autoexposure features on automatic cameras make using them almost a "no brainer." When it comes to aperture settings and shutter speeds, I find my camera is a lot smarter than I am.

Having said this, I do recommend cameras that have a manual override of their automatic features. There are times when the autofocus has trouble focusing. This is mostly caused by the camera not having something definitive to focus on. In addition, there are subjects with such contrasting values (snow is a good example) that you may want to bracket the exposure to further guarantee usable reference. *Bracketing* is used to describe the process of shooting one photo at the correct exposure, then another that is underexposed and another that is overexposed.

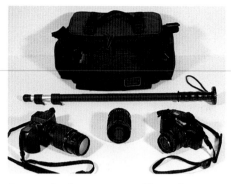

Camera Equipment You Will Need
This is the equipment I use to take my reference photos. Camera bag (top), unipod (center), 75mm–300mm zoom lens with first camera body (bottom left), 500mm lens (bottom center), 28mm–70mm wide-angle lens with second camera body (bottom right).

Lenses

No one part of your photo equipment is more important than the lens. It is the eye of the camera, and when you peer through the lens of an SLR camera it becomes your eye. Having the right lenses for your camera is essential to your picture-taking success.

Being able to compose a composition without having to change your vantage point is a prerequisite for this success. The answer to this is the zoom lens. It allows you to remain fixed in one location, while creatively selecting and composing your subject. Getting as close as you can with your camera to your final painting composition should be your goal.

Correcting Camera Distortion

A simple method for correcting camera distortion is to attach your paper to an easel or drawing table that will adjust to a vertical position. Project your reference photo onto the paper at the desired size. Slope the top of your easel or table away from the projector until the sides of the building become vertical. Then trace the image onto the paper. If the camera distortion is extreme, you may have trouble keeping the whole image in focus at the same time. This usually occurs when photographing very tall buildings or standing with the camera too close to a smaller building.

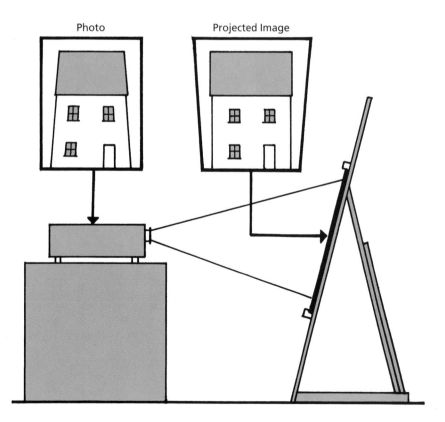

Photo Projected Image

Wide-Angle Zoom

A wide-angle zoom allows you to photograph large-scale subjects without cropping them. Sometimes when shooting a building or perhaps a street scene, it is not always possible to back up far enough with a normal lens to include the whole scene. With vast outdoor landscapes such as a mountain range, the wide-angle lens is the solution to an otherwise unphotographable subject. This lens can be manually set at 50mm. This means that the lens can be used the same as a fixed normal lens, which approximates the perspective of the human eye.

A word of caution about the wide-angle lens: If the lens is not exactly parallel to the subject, there can be considerable distortion in the image. For example, when shooting buildings from ground level it seems natural to point the camera up. This means the lens is not parallel to the vertical wall or walls of the building. Doing this causes the sides of the building to slant inward from the ground toward the top (see "Correcting Camera Distortion" artwork, at left).

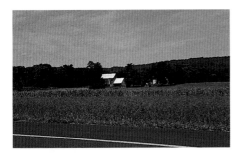

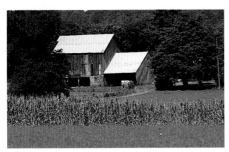

There's a big difference between using a 70mm wide-angle lens (above, top) and a 300mm telephoto lens (above, bottom).

Telephoto

I cannot remember a field trip in which I did not need my telephoto lens. I always find something I want to paint that is simply inaccessible with a normal lens. One of the most frequent reasons for this is the problem of trespassing. Almost every farm has a fence around it, especially if there is livestock. I am not about to climb a fence and trespass onto private property unless I have the owner's permission. I also think having a fence between me and any livestock is not such a bad idea. There are lots of other obstacles besides fences, such as water barriers, bridges and steep drop-offs. Without a telephoto lens, your capabilities for recording usable reference material would be seriously limited.

Lens Filters

Along with your lenses you should purchase ultraviolet (UV) filters. They have two functions. One is to eliminate haze and the other is to offer protection for the lenses. They are very cheap insurance against damaging your expensive lenses.

Camera Bag

You will also need a roomy camera bag. This will keep all of your equipment protected and organized.

Film

You cannot talk about cameras without mentioning film. Look to "Film Tips," page 17, for a thorough discussion on film brands, speed, etc.

Other Accessories

In addition to all of the above, I carry a 500mm lens and a unipod. They are not essential but can come in handy under certain conditions.

Once in a while I find subject matter to be so inaccessible that the 500mm lens can save the day. While photographing people, I try to be as respectful and unobtrusive as possible. The 500mm lens enables me to stay at a reasonable distance from the subject, and if I am lucky, they are hardly aware of

Using a Unipod

Attach the unipod to your camera by turning the mounting screw into the socket in the bottom of your camera. Standing with your feet approximately 18" (46cm) apart, adjust the length of the unipod so that your camera is just below eye level. With your left hand, hold the grip firmly and place the foot of the unipod about 12" (30cm) directly in front of you in a perfectly vertical position. Place your right hand in the correct position on the camera for taking pictures and lean slightly forward with your eye looking through the lens. As you have probably guessed by now, this procedure will join you and your camera into what is essentially a tripod.

Placing your camera on a fence post or leaning against a tree or building can also be quite effective, but this kind of help isn't always where you most need it.

Notice how my two legs and the unipod make a tripod.

my presence.

Holding the camera steady at this focal length is very important. This is where a unipod in the field can prove handy.

A tripod in the field, especially on uneven terrain, will take more time to set up than a unipod, but it will also be steadier.

Getting the Most From Your Camera

Purchasing Your Camera

Purchase your camera at the local camera store. The owner and staff are usually knowledgeable about cameras and are quite frequently professional photographers themselves. They can be of great help to you in purchasing what you need.

Remember, be explicit when explaining how you are going to use the camera and what you are trying to achieve. This will aid the salesperson in helping you select a camera that will serve you best. Do not be shy about asking questions. No question is stupid if you do not know the answer.

Understanding Your Camera

All cameras are accompanied by an owner's manual that describes in great detail every function the camera offers. Since there are certain to be some differences from one model or brand to another, study your manual to familiarize yourself with all the intricacies of your particular camera. In order to get the most from your camera, you must fully understand its functions and how to use them. In the beginning it may be a little bewildering, but with time, using your camera will become second nature. Today's cameras are user-friendly. Many functions are automatically done for you, and it makes picture taking more fun and worry free.

Remember, even though you need your pictures to be good, they are not the finished product. They are just the first step in the creation of your art. You will have the opportunity to make all kinds of changes to your reference—things like deleting or moving elements in order to improve the composition, or adding an element from another reference photo. So relax and enjoy the painting-reference experience. It will open up a whole new world for you.

Tree photo reference

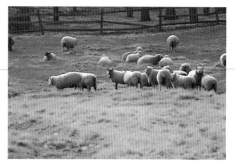

Sheep photo reference

Making Use of a Zoom Lens

I discovered this scene while on a bike ride with a friend. I knew in an instant it was a winner. Making a note of the location and the time of day, I planned to make a return trip with my camera equipment as soon as possible. Upon arriving the second time, the sheep were again clustered under the tree, but moved away as they sensed my presence. Not to be denied, I took a series of tree pictures, then used my 300mm zoom lens to shoot a series of sheep pictures. Notice how I designed my own flock in the painting by selecting certain sheep from the reference photo and arranging them to fit into the composition.

The Meadow
17½" x 25½" (44cm x 65cm)
Private collection

Film Tips

Speed

Usually, the first question after acquiring a camera is "What film should I buy?" All films are labeled with an ASA/ISO number. This number describes the amount of light the film needs for a correct exposure. The higher the number, the faster the film and the less light it needs. Conversely, the lower the number, the slower the film and the more light it needs. You might ask, "Then why not buy the fastest film and forget the slow stuff?" Things are never that simple. The faster the film, the grainier (less sharp) the final result is, while the reverse is true with the slower films.

Because I rely so heavily on longer lenses, I find the 200 ASA/ISO film a happy compromise. It is fast enough that you can use a 300mm zoom hand-held under almost all normal daylight conditions. The 200 ASA/ISO is acceptably sharp for reference photo use. It holds up well when enlarged to an 8" × 12" (20cm × 30cm) from slides, or enlarged to an 8" × 10" (20cm × 25cm) from print film.

Brand

Kodak now offers a film called Elite Chrome that provides, in their words, "extrasaturated color." I have found it to be a wonderful film for my slide work and now use it exclusively. Fujichrome is a brand of film used regularly by artists and photographers whom I respect very much. Try both brands and use what you like best.

Processing

Kodak Elite Chrome also offers a processing advantage because it does not have to be processed by a Kodak lab as its sister film Kodachrome does.

Keep in mind that no film is any better than the lab doing the processing. If you want the best assurance of top results with your picture taking, always have your film processed by a reputable lab. Saving a few dollars at your discount department store or supermarket is not a good way to guarantee the best results.

Purchasing and Storage

A sure way to save money on film is to buy it in bulk. When purchased by the "block" (twenty rolls), you can save 25 percent on the price and guarantee consistent results from roll to roll. There's no need to worry about the expiration date if you store the film in the freezer. Freezing prevents film from decomposing. Keep a small quantity in the refrigerator and the rest in the freezer. Film reaches a normal operating temperature about an hour after taken from the refrigerator. You must wait several hours after taking film from the freezer before it's ready to use. To prevent condensation from forming, don't unpackage the film until it has warmed up.

If you are flying with your cameras, be aware that film speeds of 400 ASA/ISO and higher are susceptible to the airlines' x-ray machines. To avoid film damage, keep film in a clear plastic bag to be hand checked and try not to leave film in the cameras.

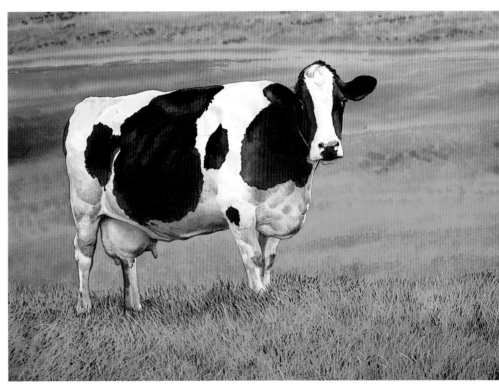

Udderly Full
19" x 26" (48cm x 66cm)
Private collection

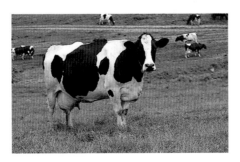

Capturing the "Perfect" Pose

The cow is one of my favorite subjects. The reference photo was shot with my telephoto zoom, using Kodak Kodachrome 200 ASA/ISO film. Judging from the painting, you might think the cow was holding perfectly still. This is almost never the case with animals; even when they are standing in place, something is always moving. When they are fairly motionless, I usually compose my picture with the shutter release held halfway down and shoot when the pose looks "perfect." If there is a lot of movement, I then take a whole series of shots, hoping to get that "just-right pose."

Light Is Everything

Light describes and delineates your subject matter. And the intensity of color directly corresponds with the intensity of the light. So without light, there is no color, only blackness. Therefore, it is important to know what kind of light is best for your subject matter. Early morning and late afternoon light work the best for my landscapes. This is especially true from April through September when the sun is higher in the sky for most of the day. The lower the angle of the sun, the more dramatic your subject will be because of the stronger lights and darks and longer shadows. I particularly love to take pictures in December and January when the sun is at its lowest angle.

Make mental notes of the time of day, weather conditions and season that work best with your subjects. A composition that barely tweaks your interest in the morning may knock your socks off in the afternoon. Another composition may be positively striking at the end of a storm but obscured during the storm's onset.

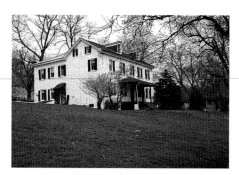

I was commissioned to paint this old farmhouse just as the trees and plants burst forth in early spring. When I arrived on location, several clouds moved in and the whole scene turned gray.

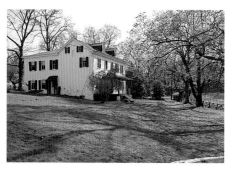

I returned on a sunny day, and I am happy to say that this time the sun stayed out. What a difference lighting makes!

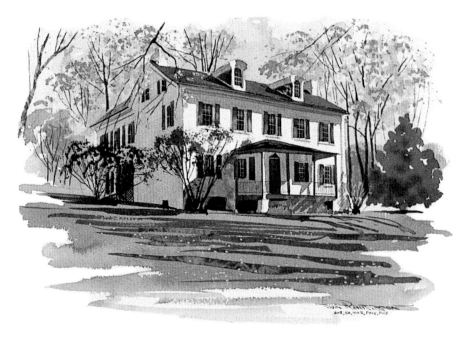

This vignette format is uncommon for me to paint but serves its purpose as a study for a larger piece.

Farmhouse
9" x 13" (23cm x 33cm)
Private collection

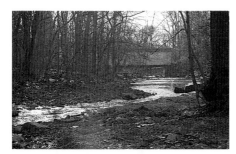

When comparing this reference photo for *Wickecheoke Creek* to the painting, notice how the drawing and values are reasonably faithful to the photo, but that the color is intensified. Satisfy your own creative instincts rather than copying your reference.

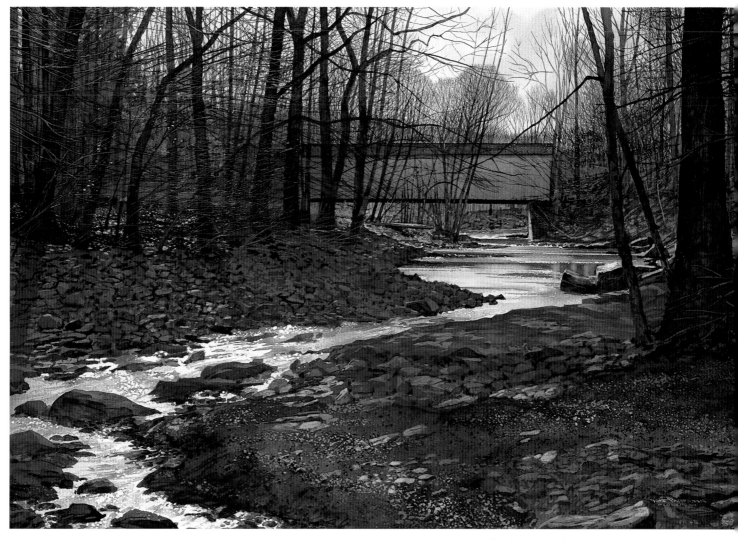

Morning Winter Sun
It was the morning winter sun that gave this scene its "Please paint me!" look. The sun filtering through the tree branches and bouncing off the creek water is visually exciting. Also the creek winding up from the lower left corner of the composition to the covered bridge is such a natural way of leading the viewer through the painting.

Wickecheoke Creek
18" x 26" (46cm x 66cm)
Collection of the artist

Composing With Your Camera

Every successful composition starts with a concept, an idea. This concept does not have to be earthshaking. It only has to perk your interest. It could be the pattern of a clothesline or how a shadow plays across a building. This is the moment when you need to compose a picture that will best show off this visual phenomenon.

Your SLR camera, equipped with a zoom lens, is perfect for this design phase of your painting. As you look through the lens, zoom in tight on what it is that first captured your interest and then gradually pull back to include more and more of the surroundings. When the surroundings become more important than your original concept, you know you have included too much information, and it is time to focus in on what first caught your interest.

You need not take any pictures during this first look if the subject is not likely to change. The second time around, as you begin to pull back, try to visualize your composition as an abstract. Arrange all the shapes in the frame in a way that maximizes the visual drama and creates an interesting path for the viewer to follow. Just because it is called the center of interest does not mean it should be placed in the center of your composition. Asymmetry is most often the key to a good

composition. The balancing act of dissimilar shapes and objects is what makes for not only a good abstract painting but also a good representational painting.

Detail Shots

You should also take detail reference pictures (such as a stone wall, an extraordinary tree, some rock formations or animal life) to be incorporated later into a complete painting composition.

Only on rare occasions will you "nail" a painting with one shot, but the closer you can get, the easier things will go in the studio.

These are typical reference photos taken for the express purpose of providing details and/or additions for other compositions.

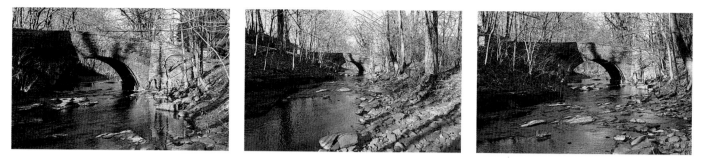

These three reference photos demonstrate composing with a zoom lens. The first is too close, the second too far, but the third is just right.

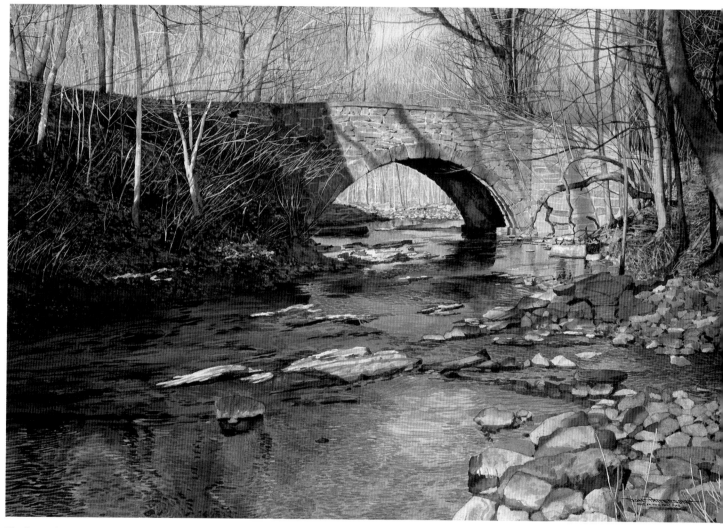

The low winter sun brings drama to this painting. The sun highlights the tree trunks and small branches against the left shadowed side of the bridge, and creates the dark and light creek banks.

Copper Creek
18" x 26" (46cm x 66cm)
Private collection

Slides vs. Prints

When taking reference pictures, I use slide film for only one reason: It is the closest thing to reality. Looking at a backlit slide seems so much more faithful to nature than a print does. Prints simply don't have the sparkle and lifelike look of a properly backlit slide.

However, prints are easy to view and handle. They can be put together when you are deciding how to combine elements from two or more pictures, and they are easy to file and/or review in photo albums. They are also easy and inexpensive to copy in black-and-white or color at your local copy center. The copies can be used in the planning stage of your painting and scissored without destroying the original prints, or you can easily order more prints from the negatives.

If you use slide film, carefully review all the slides with a slide sorter (a backlit plastic stand on which slides can be lined up in rows for easy viewing).

Using a magnifying glass makes viewing somewhat easier. Separate the slides into four groups: firsts, seconds, keepers and throwaways. Firsts are pictures you are absolutely sure you want to work from. Seconds are pictures that give you additional information about the firsts. Keepers are those pictures you feel may be useful at some other time. Throwaways are exactly what the name describes.

Slide Viewers
There are a variety of small slide viewers to choose from. Some will accept only one slide at a time, while others hold up to thirty-six slides. It is handy to choose a viewer that can be plugged in as well as run on batteries, as replacing batteries can be a nuisance. However, this convenience may be found only with the larger-capacity viewer.

Building Your Reference File

It is important to develop a filing system for your slides and prints. If you do not, you will have a frustrating time hunting through your countless envelopes and boxes of pictures for that one you want.

I like the flat metal file boxes designed to hold slides. These boxes easily hold six hundred slides in compartments that comfortably hold twenty slides apiece. A removable form located in the lid of each box corresponds to the rows of compartments. You can write a description of each compartment in the corresponding spaces on the form. It's a good idea to photocopy this form before you write on it. That way you will have a clean copy if you need to rework it.

Prints are very easy to file. They can be placed in albums, file boxes or labeled envelopes. I file all of my pictures by subject, geographical location and season. This way, for example, I can quickly find a snow scene in any given location.

The discipline of filing, not the method, is most important to keeping track of your pictures. With the advance of technology comes highly sophisticated electronic filing systems. If you are knowledgeable in this area, you may want to develop your own computerized filing system. The point is that it doesn't matter how your pictures are filed, just so they are filed!

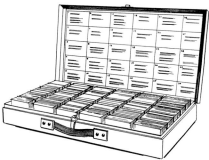

Filing box for slides

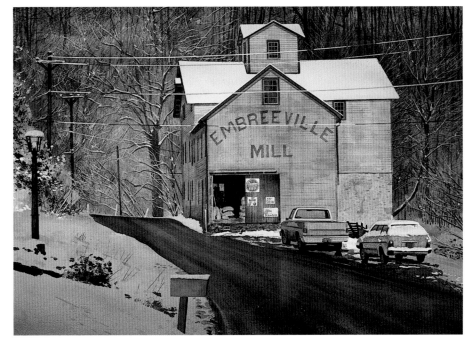

This was not a day and location you would have wanted to set up your painting spot—very sloppy and cold. Notice how I made the background color cooler than in the reference photos to better complement the warmth of the mill. I also thought the street needed to look wetter.

The Mill
20½" x 28"
(52cm x 71cm)
Private collection

Using Your Reference File
This is a small sampling of a series of pictures I took of this scene. Don't ever think you have what you need with one shot. Shift your composition in small increments. Try different angles. After studying your pictures in your studio, don't be surprised if you feel differently about the picture you thought was your "best" shot.

Proportional Enlargement

T-Square and Drawing Angle

A T-square and a 30°–60° drawing angle can help you turn your reference photo into a drawing.

Use the T-square to draw the bottom and left edges of your composition on your paper. Then draw a vertical line at the desired width of the painting. Draw the exact dimensions of your reference photo into the lower left corner and draw a line from its lower left corner through its upper right corner until it intersects with the right side of the composition. Draw a horizontal line from this intersection to the left side of the painting. You now have a rectangle that is exactly the same proportion as your photo (top right).

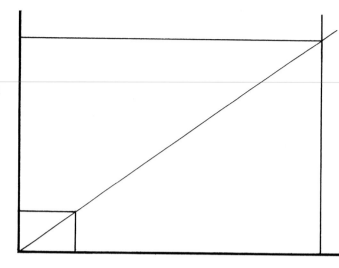

Grid Method

Due to the proliferation of mechanical enlargement methods, the old grid system is now a method used less frequently for proportional enlargement. However, for uncomplicated drawings and compositions it can be used efficiently in your studio to save time and money. Place tracing paper over the photograph you wish to enlarge. Then draw a grid as shown at center right.

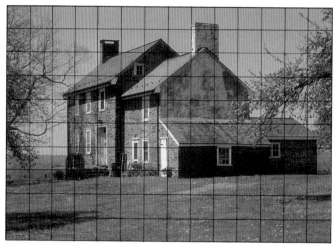

Enlarge the Grid

Determine the width (or height, whichever is greater) of your painting area. Place a sheet of tracing paper that is comparable in size over your watercolor paper and draw the bottom, right and left borders of your painting to that width (or height). As needed, use a ruler or yardstick to divide and mark off the width into the same number of equal increments as your reference photo grid. Draw in all of the horizontal and vertical lines with a T-square and large angle. Copy simplified shapes from the photo into each square of the larger grid. You now have a reasonably accurate enlargement of the photo to your desired size (bottom right).

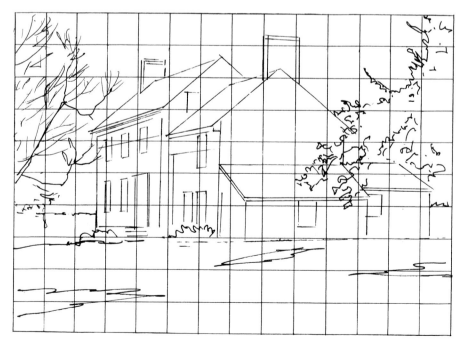

Mechanical Enlargement

Make Prints From Slides

Once you have determined which pictures you want to work with, you may wish to have prints made from these slides. Most copy centers can make color copies from your slides and prints, but in my experience, most copiers are unreliable in terms of color fidelity. Your local camera store can produce 8½" × 14" (22cm × 36cm) Kodak Image Magic prints from your slides for about eleven dollars apiece. Or you can also have a 3½" × 5" (9cm × 13cm) or 4" × 6" (10cm × 15cm) print made for roughly a dollar apiece. However, looking at an 8½" × 14" (22cm × 36cm) makes me feel I am on location. Painting from your slide in conjunction with an 8½" × 14" (22cm × 36cm) print gives you the true-to-life lighting effect of a slide and the convenience of working from a large print.

Rear-Projection Screen

With this method of slide viewing, the artist can work in front of the screen with the projector behind the screen. This provides a bright image in normal lighting. Rear-projection screens can be purchased from an audiovisual store.

Slide Projectors

All the different brands of slide projectors on the market do a good job. Make sure that the projector you select has a built-in fan to keep slides from overheating, a high and low switch for the bulb (running the bulb on the low setting prolongs its life), and a fixture that allows you to view a single slide without using a carousel (see image at top right).

Opaque Projectors

Opaque projectors are designed to project opaque copy such as photographic prints, printed copy and drawings.

Opaque projectors work quite well, but there is a limit to the size of the

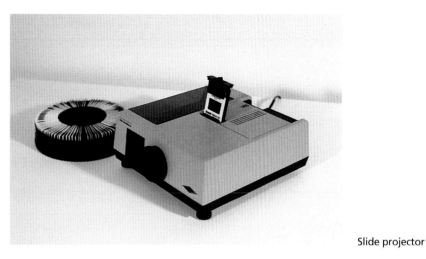

Slide projector

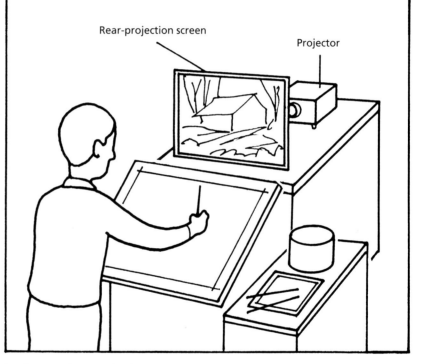

Setting up a Rear-Projection Screen
The size of the enlarged image is limited only by the size of the screen. The distance of the projector from the screen determines the size of the image.

copy that can be placed into the projector. The average size is about 6" × 6" (15cm × 15cm). There are models that will accommodate up to a 10" × 10" (25cm × 25cm) size, but they are expensive. One way around this is to have your copy reduced at your local copy center to the size the projector will accept.

Getting Your Composition on Paper

I like to get into my final painting as quickly as possible. I never do a comprehensive color sketch. However, I will make quick pencil sketches from my reference photos if I have some doubts about the composition or if I am combining elements from two or more photos. If I spend too much time on preliminary artwork, I lose my enthusiasm. For me, much of the planning has already taken place with the camera.

Prepare Your Watercolor Paper

I never paint on anything but 300-lb. (640gsm) paper because I require a flat surface for my controlled painting technique. Lighter-weight papers, even when stretched, wrinkle badly after they are wet. Try both Arches and Winsor & Newton cold-pressed papers. Arches has an incredibly tough surface and takes all kinds of abuse. If your subject requires a lot of fine detail, switch to the Winsor & Newton because it is slightly smoother.

Staple your paper onto ⅜-inch-thick (10mm) Homosote board with a staple gun using ¼-inch (6mm) staples spaced approximately 3 inches (8cm) apart. Homosote is a gray pressed-paper composition board that can be purchased from a building supply store. Ask to have it cut to the sizes you need (see top right). This board will last a lifetime. When your painting is finished, you can remove it by starting in one corner and gently lifting it straight up.

After the paper is stapled, use your T-square, angle and pencil to draw the desired size of the painting.

Run 1-inch-wide (25mm) drafting tape (a low-tack tape that does not damage the surface of the paper when removed) around all four sides of your painting. When the painting is finished and the tape removed, you have a perfectly square white border around your painting. This acts as an instant mat and makes viewing and photographing the painting much easier.

12" x 18" (30cm x 46cm)	16" x 24" (41cm x 61cm)	16" x 24" (41cm x 61cm)	
12" x 18" (30cm x 46cm)	Half Sheet 15" x 22" (38cm x 56cm)	Half Sheet 15" x 22" (38cm x 56cm)	30" x 48" (76cm x 122cm)
12" x 18" (30cm x 46cm)	24" x 32" (61cm x 81cm)	24" x 32" (61cm x 81cm)	Single Elephant 25¾" x 40" (65cm x 102cm)
12" x 18" (30cm x 46cm)	Full Sheet 22" x 30" (56cm x 76cm)	Full Sheet 22" x 30" (56cm x 76cm)	Double Elephant 29½" x 41" (75cm x 104cm)

This illustration shows how to make the most out of a sheet of Homosote. Standard watercolor paper sizes are shown as well.

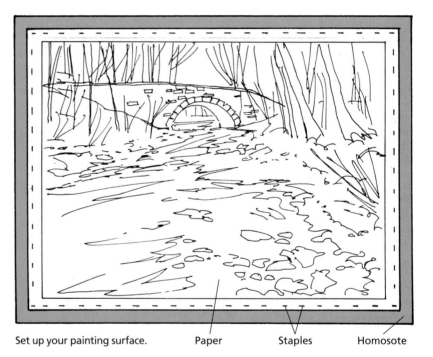

Set up your painting surface. Paper Staples Homosote

Draw Your Composition

Project your reference photos directly onto your watercolor paper and trace them with an HB or B pencil. This is an expedient process! You must work long and hard to perfect your drawing skills to be competent using mechanical drawing aids. As important as proportions are, there is much more to drawing than just the basic proportions. For example, if an artist with poor drawing skills and a trained artist with superb drawing skills were to trace the same image, the skillful artist's drawing would be infinitely better. Even though the other artist's drawing would most likely have the basic proportions correct, it would lack spirit, fluidity, form and grace. The skilled artist can breathe life and form into his drawing with an authority that no amount of mechanical aids can replace.

In order to consistently produce successful paintings, take drawing lessons as much and as often as possible. Buy a book or take a course on the principles of perspective, and draw and paint outside from nature.

Remember that the selection of subject, concept and composition belongs to the photographer. To experience the total satisfaction of creating a work of art, work only from your own reference photos.

Transfer Your Drawing

Making a drawing on tracing paper before transferring or projecting a composition to watercolor paper is often a good idea, particularly if your reference photo requires a lot of changes. Painting with watercolor is like playing chess: To be successful you had better plan your moves in advance or you will be defeated every time by this mostly unforgiving medium. It is so much better and easier to work out compositional problems on tracing paper than to make changes on your watercolor paper.

Once you are satisfied with your composition, transfer it to your paper with a graphite transfer sheet. Transfer sheets and rolls are made commercially and can be purchased at your local art supply store. It is also easy to make your own using the following steps:

1. Completely cover one side of good-quality tracing paper with the side of a soft graphite pencil lead.

2. With a cotton ball soaked in rubber cement thinner or lighter fluid, rub the graphite using a circular motion until the paper is evenly coated with a dull black surface. Caution! Never smoke or do this near an open flame.

3. Place the transfer sheet facedown on your watercolor paper and lay your drawing faceup over it, taping the top of the drawing in place so it will not move.

4. Retrace your drawing with a soft lead pencil, such as as an HB or 2B pencil. (Do not use a hard lead, for it could put grooves in your watercolor paper.) Occasionally lift the drawing and transfer sheet to make sure you have not skipped some portion of your drawing.

Your transfer sheet can be used over and over again. If any smudges appear on the watercolor paper, gently remove them with a kneaded eraser. The advantage of making your own transfer sheet, besides saving some money, is that you can custom size the sheet to fit your work.

Drawing Skills

Drawing is the foundation you must have to build on if you want to realize your potential as a realistic painter. When you are equipped with good drawing skills everything else falls into place.

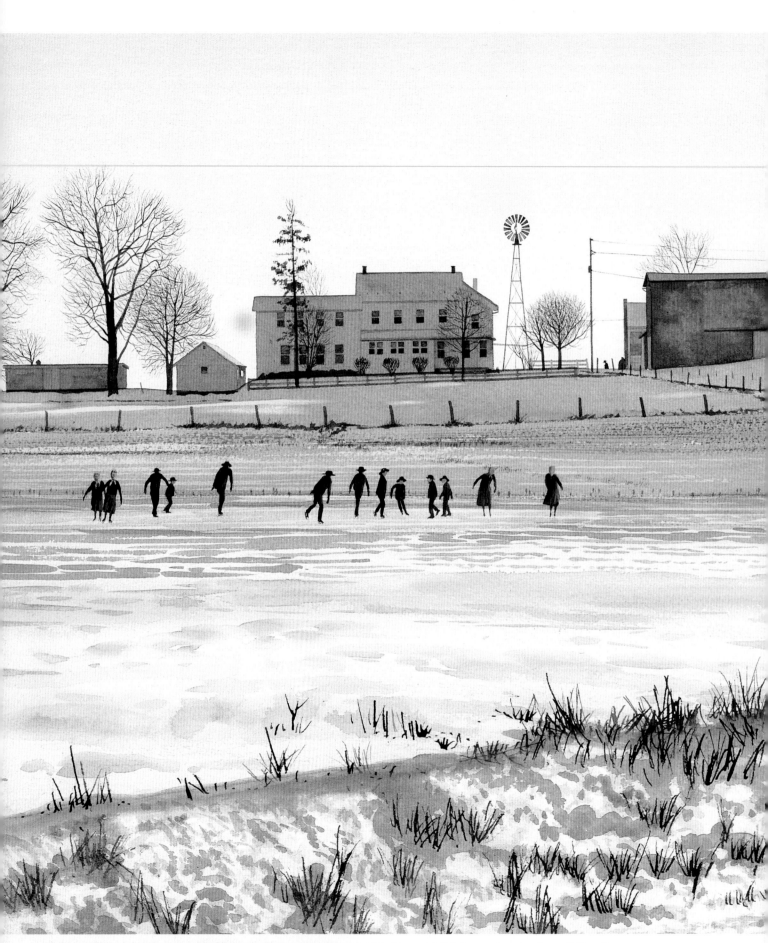

I lightened the landscape a bit and added a skating pond and buggy. I felt the overall lighting was too harsh. I wanted the scene to have a happier feeling, to go along with the fun-loving skaters. There is no reference photo for the skaters because I made them up based on my memory of another time and location.

Falling Temperatures
18½" x 27½" (47cm x 70cm)
Courtesy of Wild Goose Gallery

What a Camera Can Do for You

Painting on location is certainly the best way an artist can observe nature firsthand. "Being there" has no substitute, as painting on location forces you to intensely focus on the subject. Relying on photographs without a sound grounding in drawing and painting from life is not a good idea.

But in terms of gathering reference material to paint from, the camera has no equal. With it, you can capture and record details and moments in time that might otherwise be inaccessible or change too quickly.

This subject presents almost all of the problems associated with the difficulties of painting on location. The time of day is around 3:30 P.M. during the month of December, and the light is beginning to fade. Not only that, but it is freezing cold, and to make matters even worse, the best vantage point is from the road. A very unsafe place to be under these slippery conditions. The answer, of course, is the camera.

Capture Rapid Lighting Changes

Sunrises and sundowns are two times of day that provide us with some of the most spectacular visual effects on earth. Either can turn a rather mundane scene into a wonderfully dramatic visual event. The problem is that these events are extremely fleeting. Trying to chase a sunset with brush and paint is an extraordinary challenge. With the camera, it is easy and rewarding to simply record the whole process as it unfolds. Translating all of this into paint is naturally another matter.

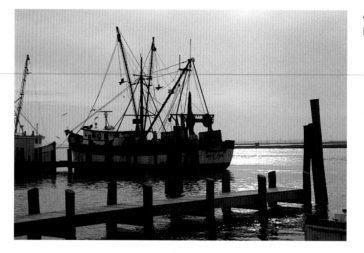

A good reference photo

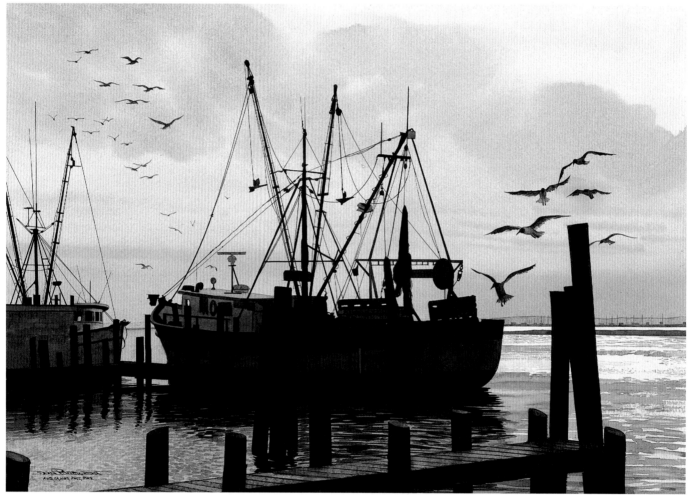

A typical example of how to make a good reference photo into an even better painting. This was accomplished by cropping the right side and bottom portions and pulling the taller pilings on the right in tighter, thereby taking some of the emphasis from the highlight on the water and allowing the viewer to focus on the boats. Adding more color to the sky and increasing the cloud definition heightens the drama. The addition of gulls gives just a touch of action and more ambience to this peaceful marine scene.

Near Dusk
14" x 20" (36cm x 51cm)
Collection of
Adm. and Mrs. Thomas J. Patterson

Capture Moving Subjects

For a realist painter without a camera, moving subjects are a major problem. I don't care how good a draftsman you are, it is an incredibly difficult feat to accurately capture a moving subject.

Throughout the centuries, artists have struggled with this problem. No wonder Degas focused a camera on his ballet dancers. Wildlife artists such as Audubon and Fuertes went on hunting expeditions to shoot wild fowl in order to have "models" from which to work. All of the dedicated wildlife artists I know have bird carcasses in their freezers. As I see it, we are very fortunate to have the camera.

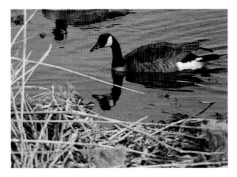

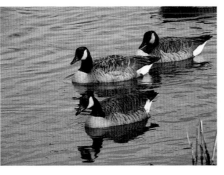

These reference photos show not only how the camera can "capture" the moving subject, but also gather details of the environment.

With a subject like this, I applied masking fluid over the geese and reeds, painted the water, removed the masking fluid and then painted the geese and reeds in that order.

Three of a Kind
20" x 28" (51cm x 71cm)
Private collection

You Don't Have to Freeze While Painting

Weather is another major reason for resorting to the camera. I have been out in weather so cold my fingers were stiff. Imagine trying to paint a watercolor with stiff fingers and frozen water. How about in the pouring rain or even sitting in the blazing sun for hours because that was the best vantage point. I will never be convinced that suffering the elements promotes better art. It is hard enough for me to be at my best without having to contend with cold, heat, wind or insects.

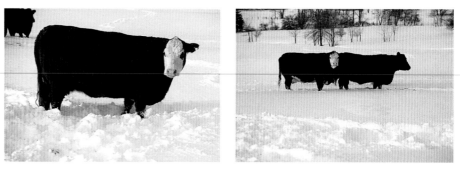

Operating a camera is next to impossible with any kind of warm gloves on, so this became one of those "stiff finger" days.

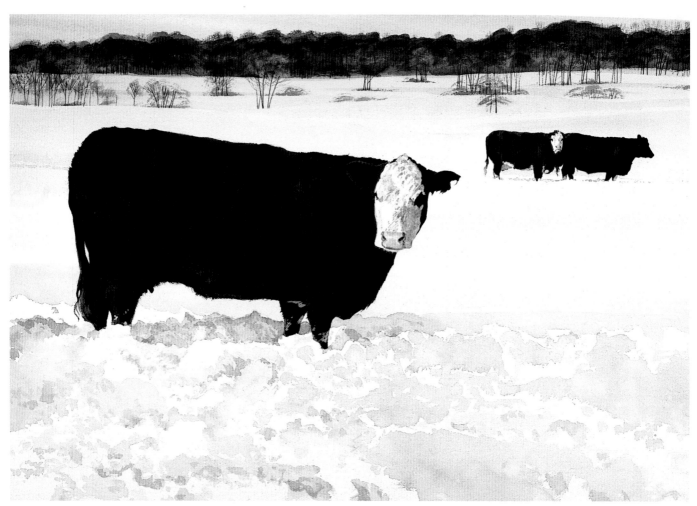

The cows didn't seem to mind the cold one bit, because most of them remained huddled together against the cold. Fortunately, some of them did separate from the group, and I was able to take some pictures I could make into a composition.

Cold Beef
20" x 27½" (51cm x 70cm)
Collection of the artist

Paint Subjects out of Season

I do not like to paint the same subject matter over a long period of time. I need a change in order to keep from becoming stale. A dramatic switch in subject matter always renews my enthusiasm. One sure way to do this is to paint a season different from the one you are presently living in. Sometimes a snow scene in July is just what the doctor ordered. Having a photographic file separated by seasons makes this a simple matter.

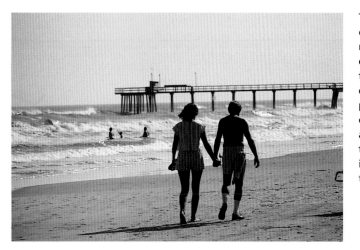

This was another one of those shots that required very little changing. I shifted the figures just enough so the pier pilings did not center on their heads. I also added two gulls in the surf and cropped in tighter from the top and right sides.

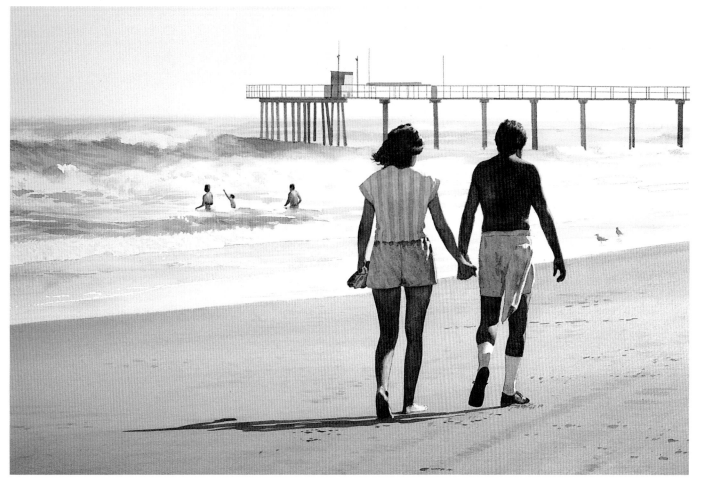

This is certainly a narrative painting. That was the easy part. Getting the light right and drawing the figures correctly was the challenge.

Summer's End
13½" x 20" (34cm x 51cm)
Private collection

Thoroughly Study Your Subject Matter

If there is one sure way to guarantee a failed painting, it is to not fully understand your subject matter. Never start a painting without first feeling confident that you comprehend the entire content of the composition. Because still photos stop any motion and the light is not changing, they go a long way in helping you understand what makes any subject tick. Lack of information is a terrible thing for the realist, and it is the camera that makes it possible to permanently, quickly and accurately record your reference material. It is also much better to have too much information than to suddenly realize you don't have enough. Having to fake it is not a good way to work.

I used the reference photo on the left for the overall cropping and the one on the right to create a more interesting foreground.

There are many different water surfaces, because water is a moving reflective surface. This can be confusing unless all movement is stopped with a camera, making it possible to analyze what is really going on with the watery patterns.

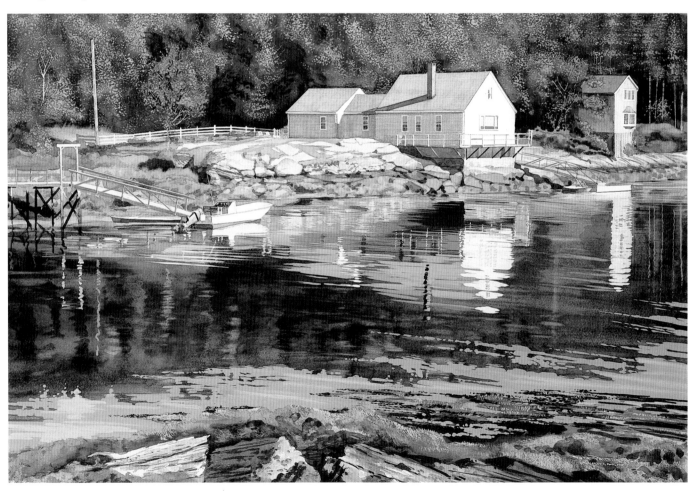

If this scene had no water, I never would have painted it. The water provides all the excitement. I particularly love the introduction of blue brought into the palette by the reflection of the sky.

September Reflections
18½" x 27½" (47cm x 70cm)
Collection of the artist

Preserve Perishable or Changing Subjects

There are so many subjects that can change before you have the time to properly study and paint them. Cut flowers and fruit are two of the first things we think of, but there are others, such as melting snow and ice, skies and clouds, and leaves turning color. Construction work is even a possibility. Think of a barn raising, for instance. It is a comforting thought to know you have the technology at your fingertips to record on film what you choose to paint.

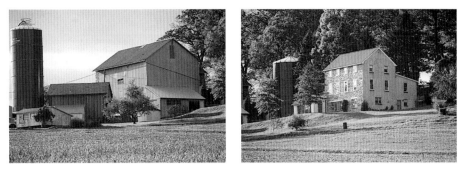

These reference photos show how to break out the details with a zoom lens.

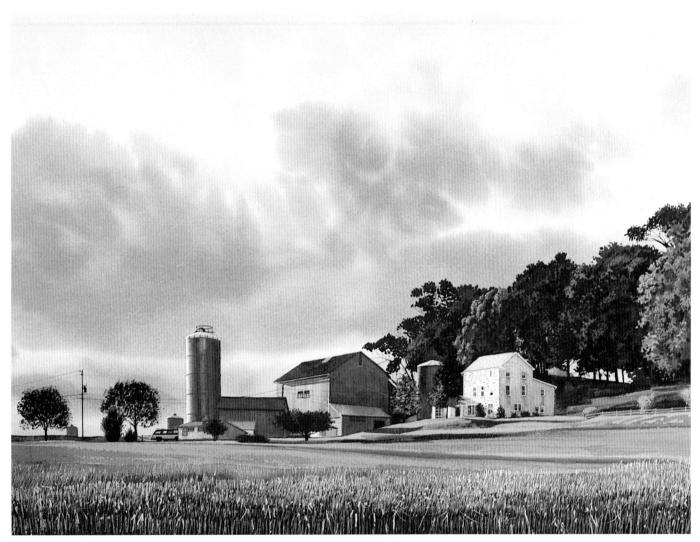

This painting contains both a fast-changing sky and lots of architectural detail. In addition, it was autumn, and the peak seasonal color would not last very long.

Storm Front
20" x 27" (51cm x 69cm)
Collection of Robin Brueckmann

Zoom in and Record the Details

You do not want to find yourself short of information after you have started a painting. I find this to be one of the greatest advantages in using a camera. The practice of photographing details is particularly helpful with complex subject matter, such as a building with a lot of architectural complexity. Being able to look at enlargements of details in your photograph gives you the confidence to paint with authority because they are of enormous help in fully understanding your subject.

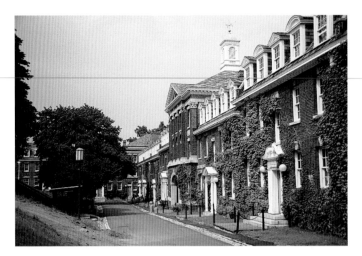

After carefully composing the overall composition, I then systematically recorded the details with my 70mm–300mm zoom lens.

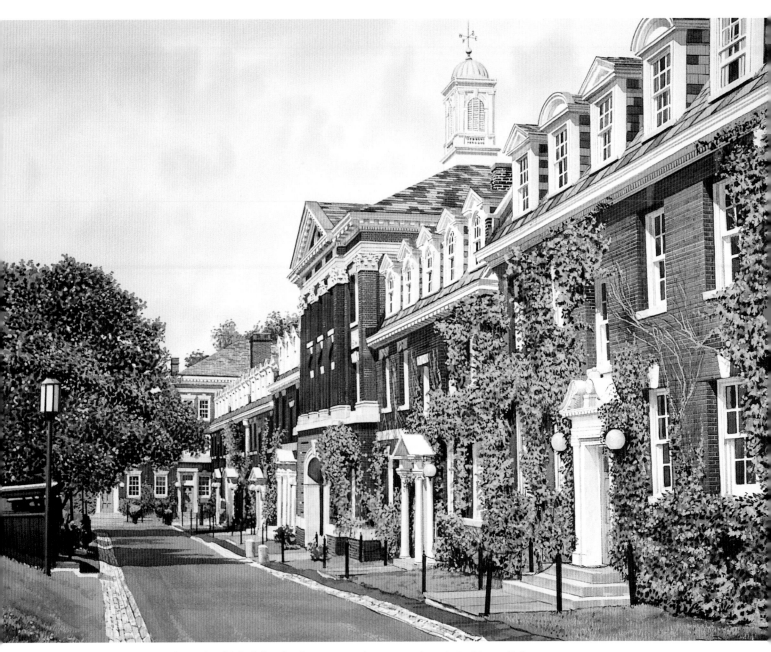

Because I was commissioned to paint this building for the purpose of an alumni print edition, architectural accuracy was mandatory.

Quadrangle Residence Halls
21" x 26" (53cm x 66cm)
Collection of Rensselaer Polytechnic Institute

Capture the Moment

So many times the camera has enabled me to capture the moment. Sometimes that moment is light-related—it may be the position of a cast shadow, or when the sun suddenly streams through a cloud break. Moving subjects can create a moment at any time, and being ready with your camera is the only way to capture it.

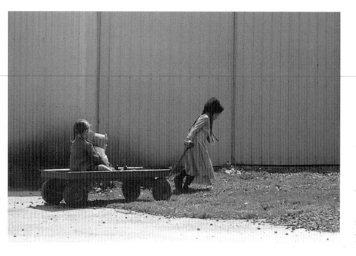

This photo opportunity lasted only seconds. These Mennonite children were heading for their front porch, and I had time to get only one shot from my car. Fortunately, it was a good one. This kind of experience has happened to me time and time again. Relying solely on a sketchbook will cost you many a concept.

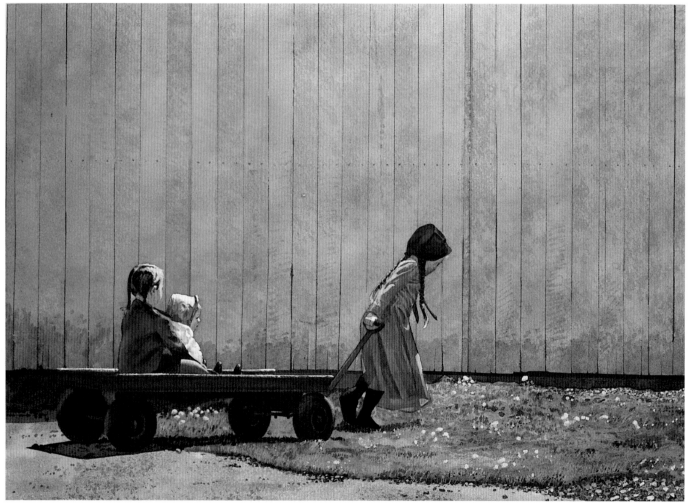

Making the barn siding more rustic, deepening the dirt color and adding a few more dandelions were all that was required of this subject.

A Sunday Afternoon
20" x 28" (51cm x 71cm)
Collection of Mr. and Mrs. William Pfaff

Keep an Open Mind

When taking a field trip to find subjects, it is OK to have preconceived ideas as to what you want to find, but best to keep an open mind and take whatever the day brings.

Having one or two fellow artists along is also a good idea. More than one pair of eyes with you is a kind of insurance against missed opportunities. I know from experience that having some company along enhances your chances of not only having a more productive day but also one that is more enjoyable. Sharing ideas and experiences with fellow artists has definitely made me a better artist.

I never expected to find this kind of subject matter on this particular trip. I was anticipating big vistas with farms and snow-covered fields. As things turned out, this became one of my favorite paintings.

There were two reasons for needing a camera to make this painting: one, it was too cold for painting outdoors, and two, the best vantage point was from the middle of the road.

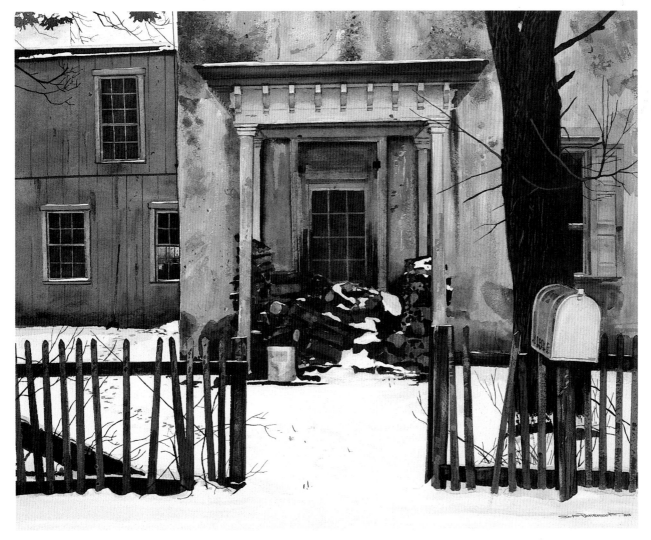

The reference photo was a little too dark, so I lightened the painting and cropped in on the left side to keep the viewer focused on the porch area.

Winter's Supply
21" x 26" (53cm x 66cm)
Collection of Mrs. Robert A. Patterson

Getting the Right Pose

I frequently include animals in my paintings because I feel they add so much life and interest to my compositions. Besides, I simply love animals. They evoke warm feelings in me, and I just love to study and paint them. Even so, getting the right pose is not always a simple matter. The saying "Patience is a virtue" is certainly true when it comes to photographing animals. There are times when the only thing to do is wait it out and hope that sooner or later your subject will do something worthy of painting.

These are just a few reference samples showing how subtle movements can make all the difference. I shot almost an entire role of film, hoping to get just the right pose.

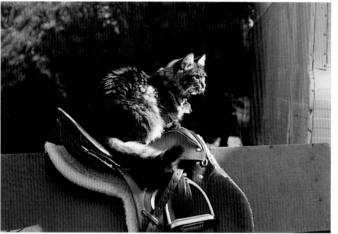

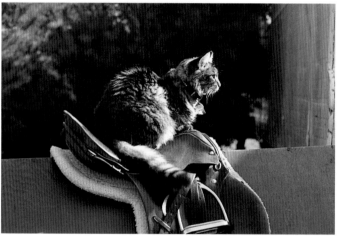

This pose was a natural choice for the final painting.

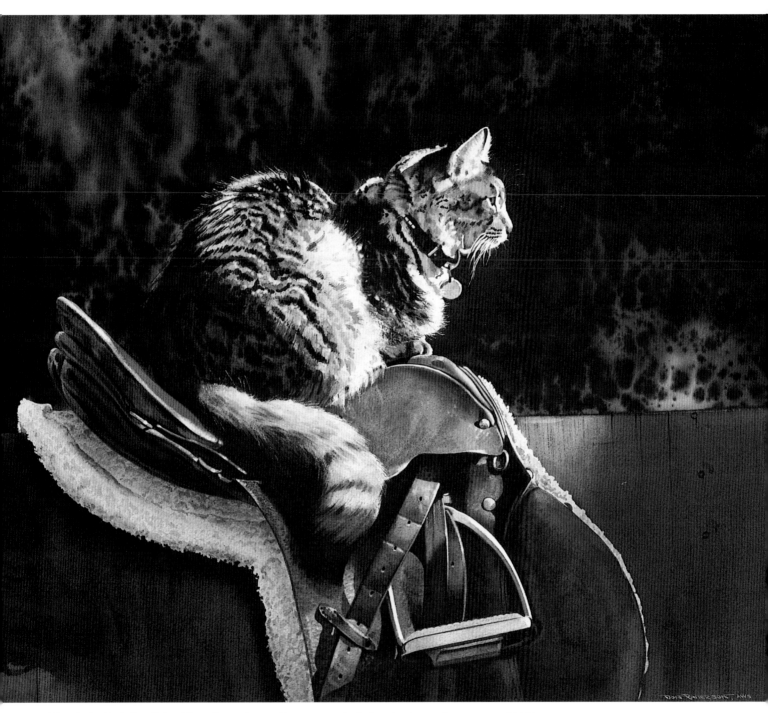

This painting includes all the things that make a subject extremely challenging but at the same time very rewarding if done well. The drawing must be good if the painting is to have any chance at succeeding. The final execution of all the textures also has to be perfect. The lighting is critical, and last but not least, the positioning of the cat is paramount.

Tabitha
21" x 25" (53cm x 64cm)
Private collection

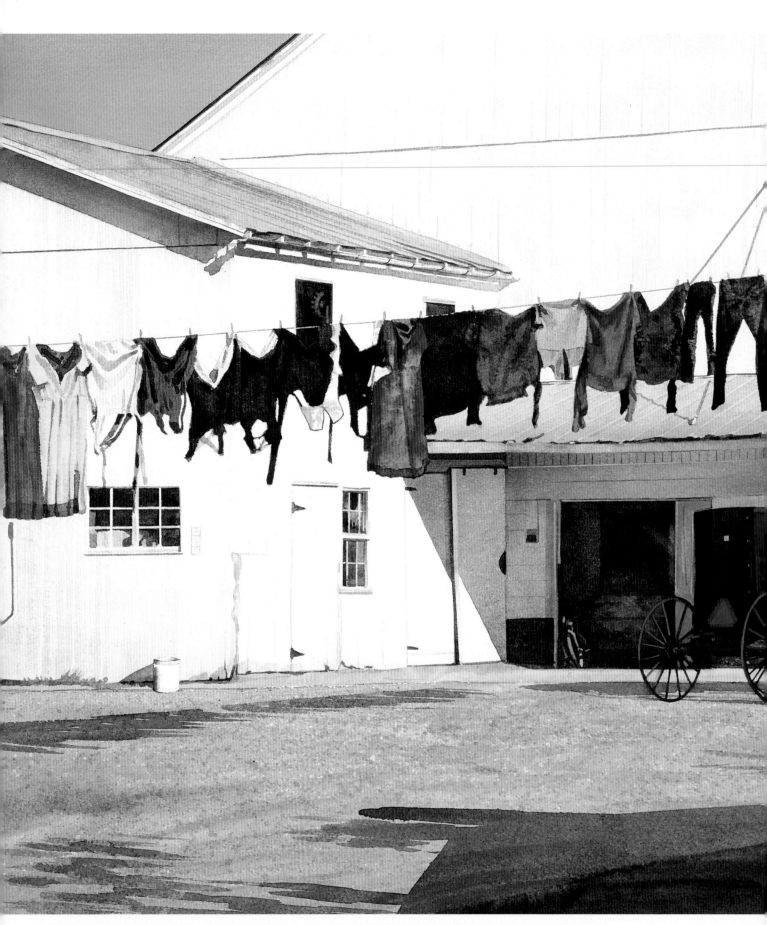

The Mennonite clothesline of the photo is transformed into an Amish clothesline. You will never see blue jeans and patterned clothing in Amish attire. I made this change in order to strengthen the narrative quality of the painting. That is also the reason for adding the buggy on the driveway and deleting the front end of a car in the lower left corner.

Country Hangout
18" x 27½" (46cm x 70cm)
Private collection

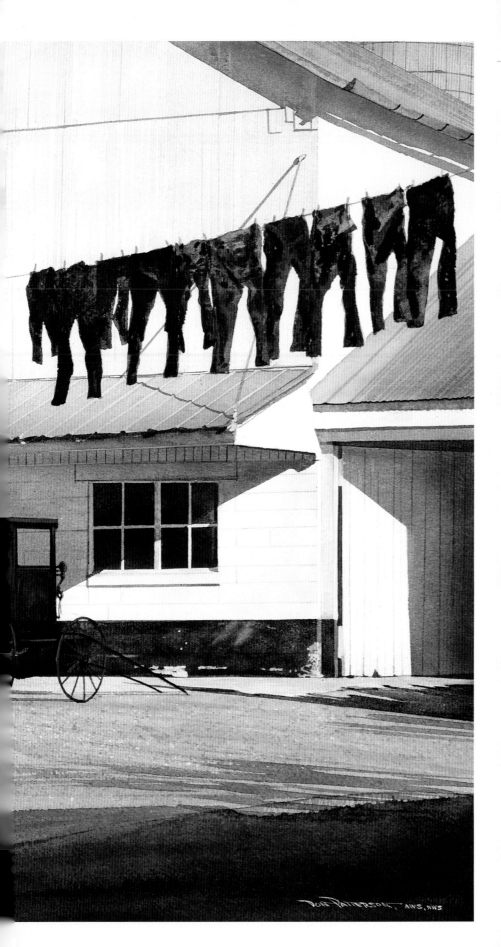

Painting From One Photo

Painting from one photo sounds like a straightforward, uncomplicated procedure. However, you'll often find that the camera has not picked up all the elements necessary to make a good painting. More often than not you will need to make some changes from the photo: cropping, changing the background, moving or deleting elements, altering or even adding elements to further tell your story. This chapter takes you through a number of paintings and demonstrations that highlight and illustrate the types of edits that may arise as you paint from one photo.

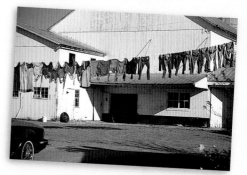

Look carefully at the clothesline and other details in this photo and compare them to the finished painting.

Deleting Elements

Deleting is the chief topic present in the painting below. In the reference photo at right it looks like a stone-and-steel support runs along the bottom portion of the covered bridge. This is actually another bridge that was built directly alongside the covered bridge in order to expand the roadway. I deleted this newer bridge because it obstructed the covered bridge, and to show how this scene looked in the past. Hence the title *The Way It Was*.

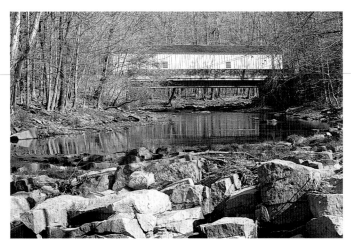

Reference photo

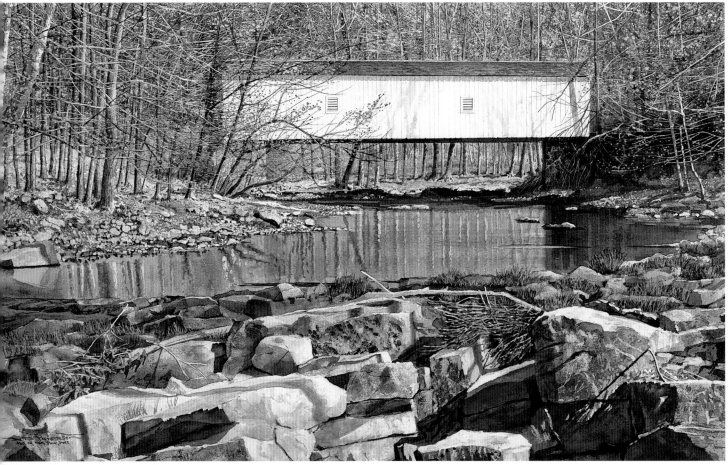

The Way It Was
15" x 25½" (38cm x 65cm)
Collection of the artist

It is pretty obvious that deleting was done when you compare the painting below to the reference photo at right. I was immediately attracted to the weathered old house, but the best view included the overpowering evergreen tree on the right. With that gone and some minor cropping, I had what I wanted.

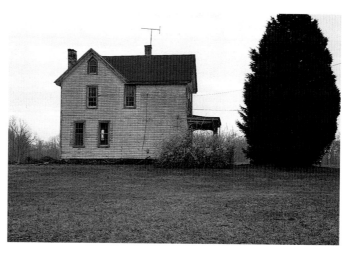

Reference photo

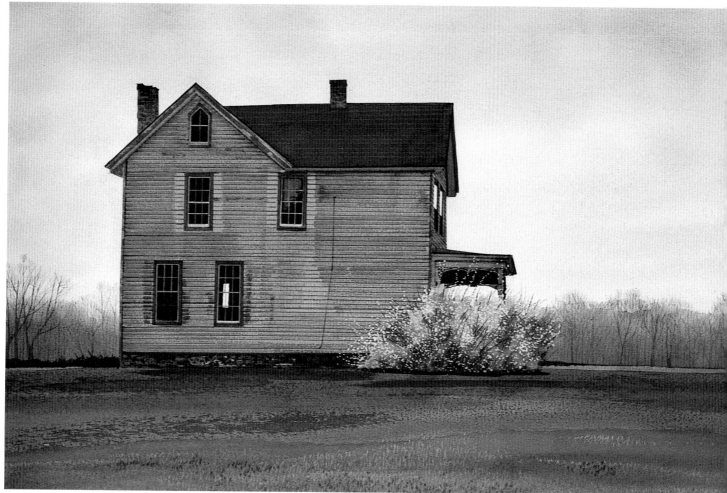

First Bloom
13" x 20" (33cm x 51cm)
Collection of the artist

Cropping With Your Camera

It is possible to crop a subject in the field with your camera and come away with the possibility of more than one painting from a single subject. At the very least you will have choices. If you develop proficiency using the camera to obtain reference material, you can make your paintings that much easier to tackle.

Comparing the following reference photos with the paintings, you will notice that *Marsh Grass* (below) and *Tidewater* (facing page) are cropped only slightly.

I should mention that I happened upon this subject by sheer chance while bicycling with friends at the seashore. Luckily my camera was stored in my handlebar bag.

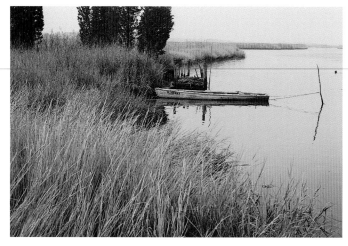

Reference photo

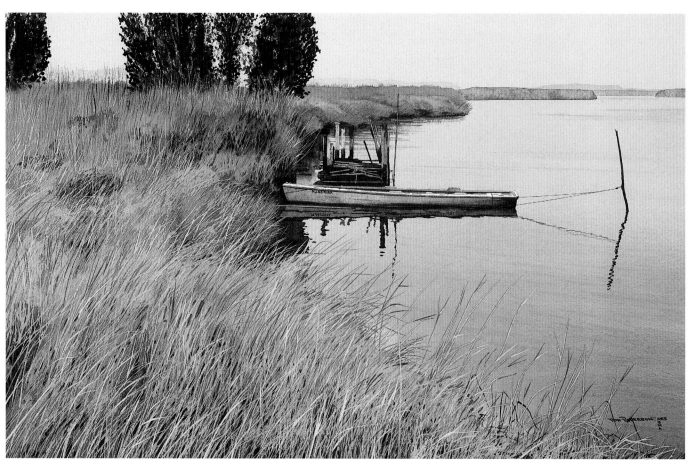

Marsh Grass
16" x 25" (41cm x 64cm)
Private collection

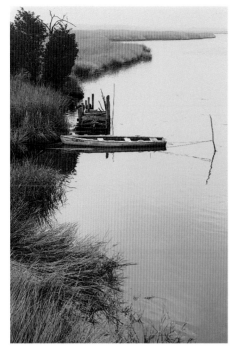

Reference photo

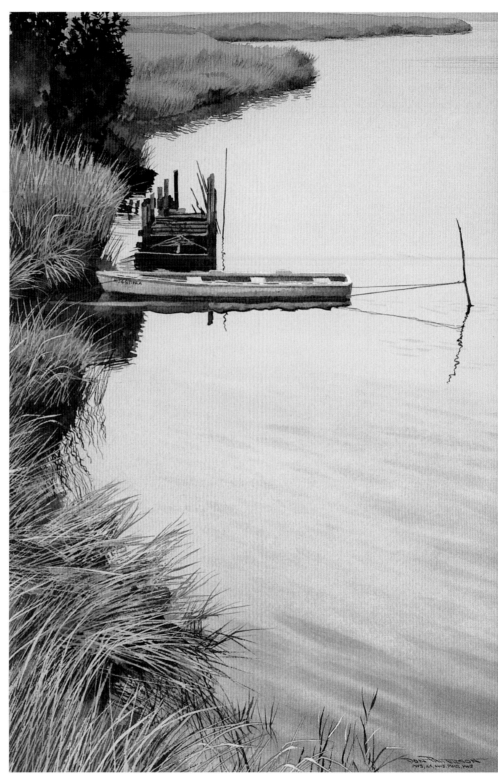

Tidewater
19½" x 13" (50cm x 33cm)
Private collection

More Cropping With Your Camera

Lonely Mooring (below) required major cropping, because I felt the background was overpowering the boat. No matter how careful you are cropping with your camera, you can expect to do more cropping in your studio.

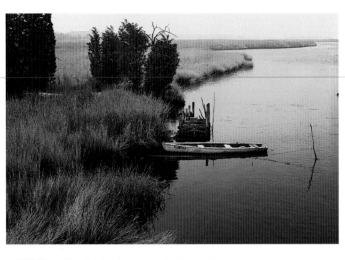

Reference photo

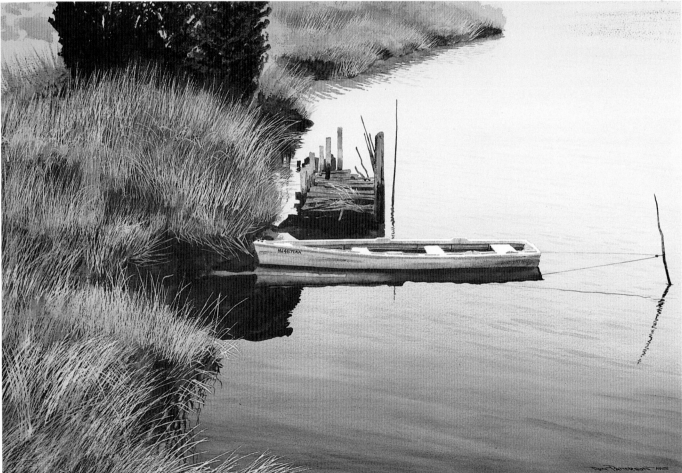

Lonely Mooring
19" x 27" (48cm x 69cm)
Private collection

Cropping With **L** Shapes

Cropping with **L** shapes is a perfect backup method to camera cropping. There are times when after your film is processed you will not be satisfied with your camera cropping. The most frequent reason is that the proportions that work best for your painting composition do not fit the slide or print proportions. This is an inherent shortcoming in cropping with the camera, but is easily fixed with the use of **L** shapes on prints or photocopies made from slides. Cut two **L** shapes out of heavy paper and lay them on top of your print to form an adjustable mat. These illustrations show how cropping with this method produced three usable compositions from one photo.

Another Cropping Tool

Because I work with slides, cropping with a projected image works quite well. Holding a small strip of heavy paper in front of the projector's lens is an excellent way to crop the projected image for quick visualization and decision making.

Cropping Elements

The October sun streaming across the farm in the reference photo at right was the main attraction for me when I happened upon this scene. Not wanting to take the focus off the farm buildings, I decided to crop most of the foreground and some of the sky from the reference and to make this into a long horizontal composition.

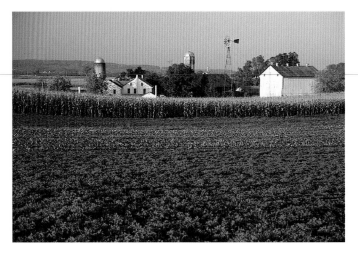

Reference photo

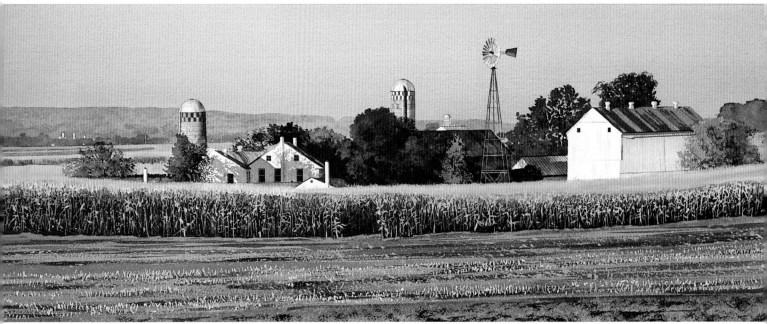

Indian Summer
11" x 27¾" (28cm x 70cm)
Private collection

Adding, Deleting and Cropping Elements

As you develop a painting from a photo, you may find you need to make multiple changes in order to come up with a successful composition and final piece of art.

The reference photo (right) for the painting below needed some emotion, a story, so I added a buggy to the scene to strengthen the narrative. I lightened the cast shadow on the barn in order not to draw too much attention away from the clothesline or buggy. I deleted the houses on the left of the reference because I felt they were an intrusion, and I severely cropped the foreground to keep the focus entirely on the barn.

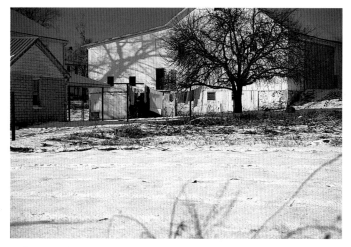

Reference photo

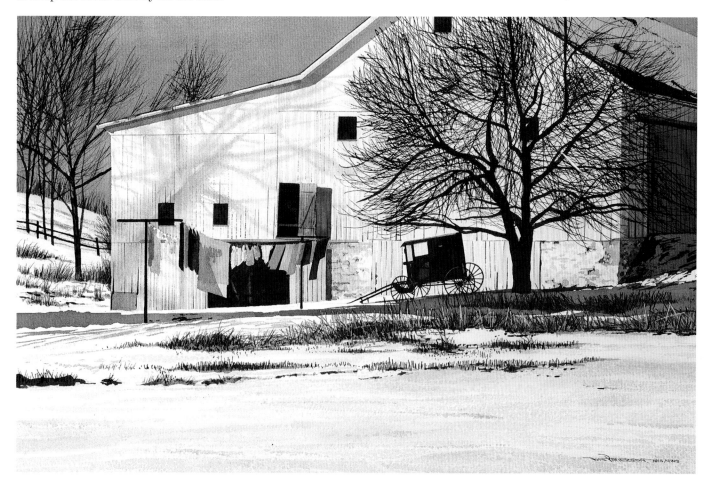

The Sunnyside
10¾" x 18½" (27cm x 47cm)
Private collection

Altering and Deleting Elements

When photographing and painting animals into a landscape, it is frequently necessary to move the subjects around for a better composition and overall effect. In the reference photo at right, the juxtaposition of the cows, coupled with their black-and-white markings, provides a knockout abstract, and the subject matter is irresistible. However, the composition of the photo needs some cleaning up. The cows on the embankment are distracting, and the tree branches coming down over one of the cows gets in the way. In addition, more black-and-white patterns on the cows would add interest, especially on the two solid black cows.

Without a camera, the painting below would not have been possible. The cows were moving at all times, and their positions in the reference photo lasted only seconds before they separated.

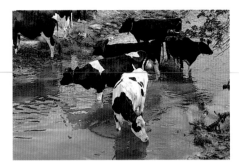
Reference photo

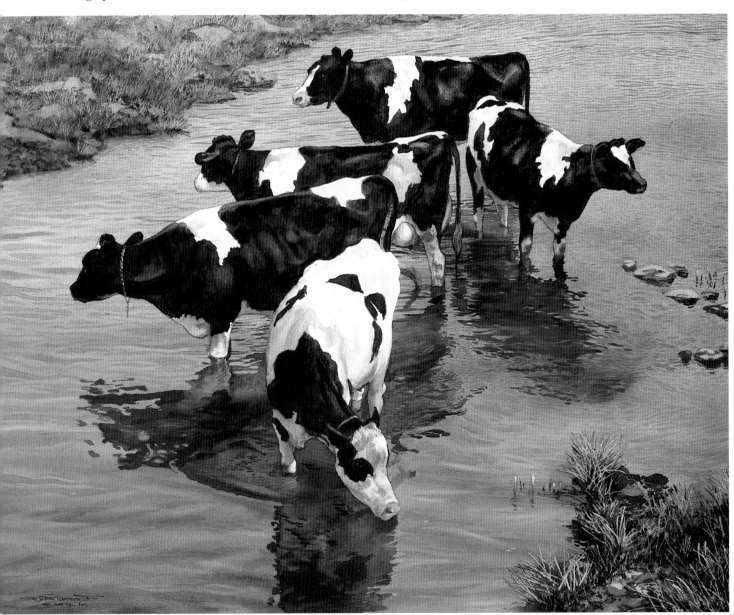

Bovine Bliss
19" x 24½" (48cm x 62cm)
Collection of the artist

Simplify the Background

Some might say the middle ground of a painting is the most important because the center of interest is most likely located in this area, but I would disagree. If your paintings are to be totally successful, then the foreground, middle ground and background must all be properly realized. Changing the background can make all the difference to a painting.

The need to completely change a background occurs much more frequently with intimate subject matter than with broad landscapes. In a broad landscape the background most often takes its natural place. The background in a more closely focused subject is often in objectionable competition with the center of interest.

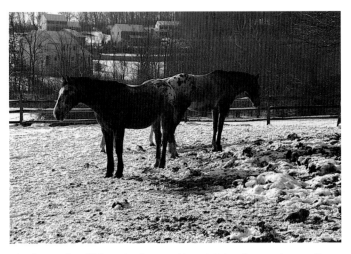

Altering or simplifying a background is certainly a frequent necessity, and this photo is a typical example. The houses beyond the trees were a poor background for this equestrian scene. Keeping that in mind, a little bit of cropping was all that was required.

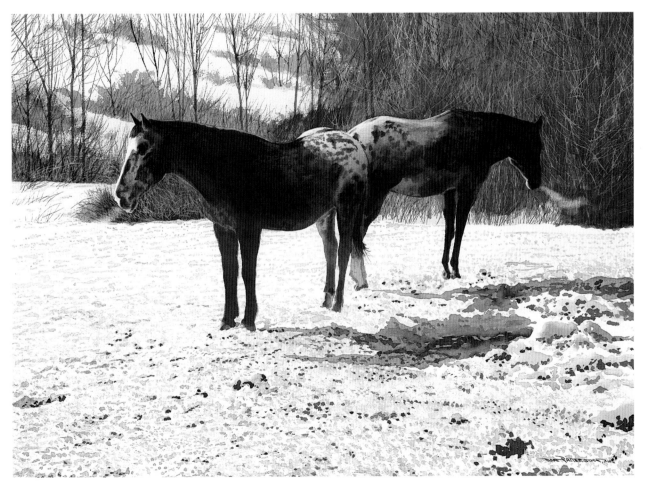

Notice the horses' breath in the frosty air. Never miss an opportunity to increase the narrative quality of a painting.

End to End
20" x 27½" (51cm x 70cm)
Collection of Robin Brueckmann

Create an Atmospheric Background

Painting an entire dark atmospheric background retains the drama found in the photo and provides a sense of space. Try to create backgrounds that give the viewer an almost "reach into" look. This background was painted with a wet-into-wet spatter technique followed by adding texture with a natural sponge. In order to keep all of the focus on the subject, the table had to be deleted.

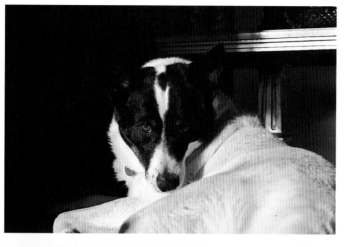

This reference photo of Topper represents an opportunity that lasted for only a second or two. I found him asleep on the floor with the sunlight streaming through the window at a perfect angle. I focused my camera and then quietly uttered his name. His head came up, and I pressed the shutter release. One shot was all I got before he changed position. In situations like this, there is no time to worry about backgrounds. Capturing the subject is all that matters.

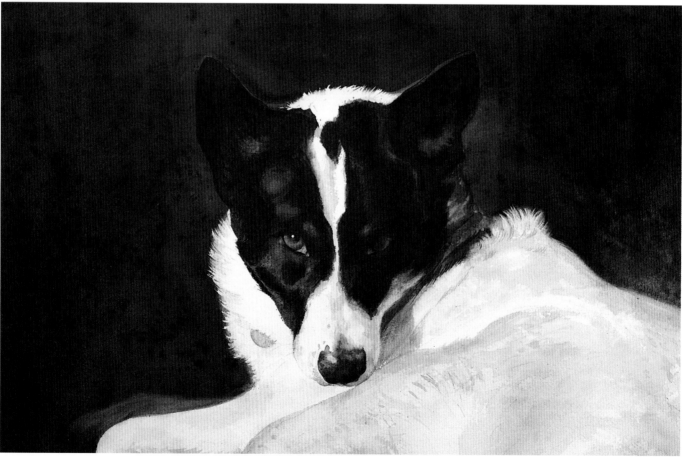

Topper
19½" x 26" (50cm x 66cm)
Collection of the artist

Heighten Drama With Your Background

When I took the photo below I knew the background would be much too busy and would have to be either modified or replaced. After further study, I decided a sky background would be very appropriate for this subject.

When replacing a background, always make sure it is appropriate in terms of environment and/or content.

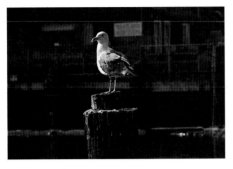

Reference photo

I painted the wet-into-wet stormy sky because of the heightened drama created by the value contrasts and the harmony of color it provided. As a bonus, the background inspired the title *Storm Watch*.

Storm Watch
18" x 13"
(46cm x 33cm)
Private collection

Bring Attention to Your Subject

The very literal backgrounds in these photos are completely wrong for my idea to do portraits of these animals. Busy backgrounds take too much attention away from the subject.

However, an out-of-focus background gives a sense of the outdoors and provides a nonobtrusive backdrop for these subjects.

I might add, this rooster was so full of himself he actually stayed in one place and posed the whole time I was taking pictures of him.

Something to Crow About
19" x 13" (48cm x 33cm)
Private collection

With all of the intricateness contained in this subject, the last thing I wanted was the full landscape quality of the background.

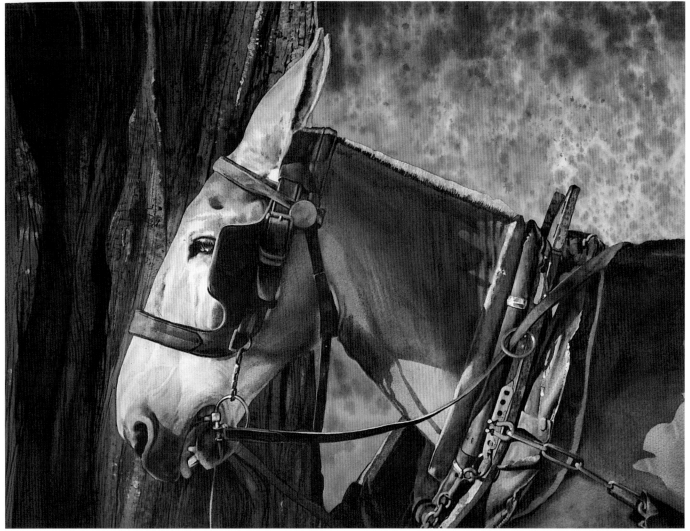

Since the mule was already resting under a tree, the soft wet-into-wet green backdrop is not only appropriate, but it provides just the right contrasting color.

Timeout
21" x 27½" (53cm x 70cm)
Collection of Robin Brueckmann

Find Two Paintings in One Photo

Getting two paintings from one photo does not happen on a regular basis, but it is important to be aware that with a little imagination and a lot of observation, a reference photo can often be a stepping-stone to something quite different from your original intent.

I painted *View From Quarry Road* (below) in February 1996, and it was not until December 1998 that I observed the wonderfully large red sun of *Winter Sun* (facing page) setting in the same location.

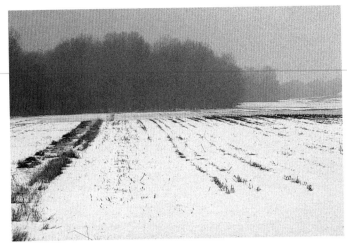

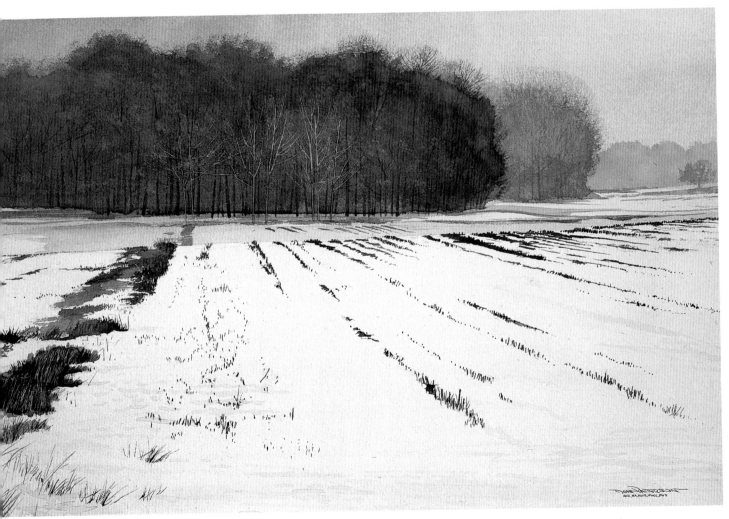

This painting was inspired initially by the reference photo.

View From Quarry Road
17¼" x 26½" (44cm x 67cm)
Private collection

I live less than three miles from this spot and pass it frequently on my way to and from a nearby shopping center. On the day I saw this sun, I did not have a camera with me, but I was so taken with this moment of nature's splendor, I stopped my car and simply took it all in. There wasn't any snow on this day, but it really didn't matter for I was interested only in the sun and sky; I already had a reference photo for the rest.

Winter Sun
12" x 18" (30cm x 46cm)
Collection of the artist

Capturing Atmosphere

One of the reasons I love the four seasons is because they bring continual change to the landscape. Every season brings its own kind of beauty, look and feel to each day. In this demonstration the goal is to make the viewer vicariously experience the serenity and singular beauty of this gray-clouded and snow-covered pastoral scene. On a gray day such as this, the subject matter tends to be low-key, and even the snow is considerably darker than you might think. Getting the values right is crucial to the success of any painting, and that is why this demonstration is important to your development as a painter.

A Word About Masking Fluid

Masking fluid is a rubber-based latex liquid that can be applied with either a brush or pen. Winsor & Newton Art Masking Fluid is my brand of choice. If applying mask with a brush, use only worn or cheap brushes, as the masking fluid will be hard on them. When mask is dry, you can easily remove it with a rubber cement pickup.

Use rubber cement thinner, then soap and water to clean the mask from your brushes. Try applying mask with a top-quality ruling pen to achieve fine lines for tree branches, grasses, etc.

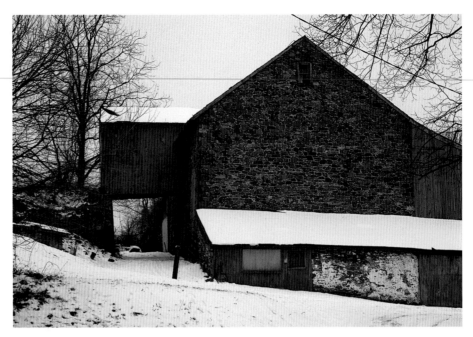

STEP ONE: **Study the Reference Photo**
It is not necessary to make any major changes to this photo. A little cropping on the bottom and the right side will help bring the focus to the barn. Eliminating the yellow fiberglass panel that covers one of the bottom windows will clean up the scene.

Paper
300-lb. (640gsm)
 Arches cold-press

Palette
WINSOR & NEWTON
Yellow Ochre
Cadmium Lemon
Burnt Umber

M. GRAHAM & CO.
Phthalocyanine
 Blue
Quinacridone Rose
Payne's Gray
Quinacridone Violet
Neutral Tint
Burnt Sienna
Raw Umber

Brushes
No. 0 round sable
No. 2 round sable
No. 4 round sable
No. 12 round sable
No. 3 rigger
¾-inch (19mm) oval
2-inch (51mm) flat
 latex

Other
1-inch (25mm)
 drafting tape
Winsor & Newton
 Art Masking Fluid
Small natural sponge
Paper towels
Ruling pen
Artist's bridge

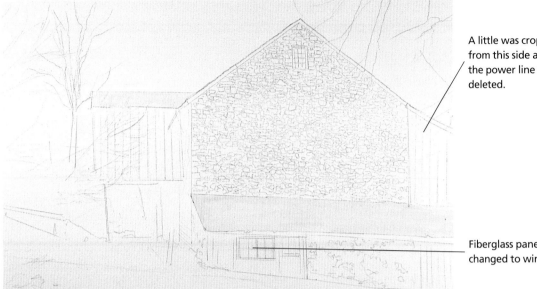

A little was cropped from this side and the power line was deleted.

Fiberglass panel changed to windows

STEP TWO: **Paint the Light**

After you have completed your basic drawing, it is time to paint the "common light." This common light covers and influences all the colors in your scene. To paint it, use your 2-inch (51mm) flat latex brush to apply three glazes of about 5 percent color intensity over the entire surface, using the following sequence: Yellow Ochre, Cadmium Lemon and Phthalocyanine Blue. Make sure glazes dry between applications. Once the final glaze is dry, cover the rooftops and tree branches in front of the left side of the barn with masking fluid.

STEP THREE: **Build the Common Color**

Add another pale glaze of Cadmium Lemon over the entire painting to brighten it somewhat. Then add a pale glaze of Quinacridone Rose over the sky and barn and apply another pale glaze of Phthalocyanine Blue over the ground snow.

Now you are ready to tackle the sky washes. In the reference photo, the sky is a very flat gray. To create interest, give the sky a more mottled look. To do this, wash the sky area with a Payne's Gray/Phthalocyanine Blue mix. When this dries, wet the entire sky and use a ¾-inch (19mm) oval brush to stroke in clouds of a slightly darker value mix of the same two colors. This wet-into-wet technique works best if your board is flat and the paper has a slight even sheen, not puddled.

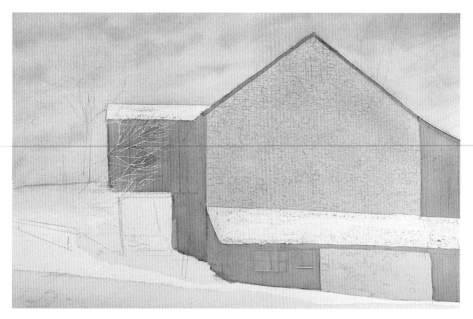

STEP FOUR: **Begin the Barn**

By now you are probably thinking, *Does this guy ever mix a final color?* The answer is yes, but most often on smaller areas like tree branches and leaves. I don't mix final colors all at once for two reasons. First, by building up to a color with glazes, your colors remain pure and unmuddied, and second, building up color with glazes is a fail-safe way to arrive at the right value (lightness or darkness of a color), which is very important to the success of your paintings. If the values aren't right, nothing else matters because your painting will never fully succeed.

To build up the color of the barn, glaze a Payne's Gray/Phthalocyanine Blue mix over the whole barn with a no. 12 round sable and follow that with a glaze of Yellow Ochre. After that dries, apply glazes of Phthalocyanine Blue and Quinacridone Violet over the wood portions of the barn. Wash a mix of Phthalocyanine Blue and Quinacridone Violet over the foreground snow.

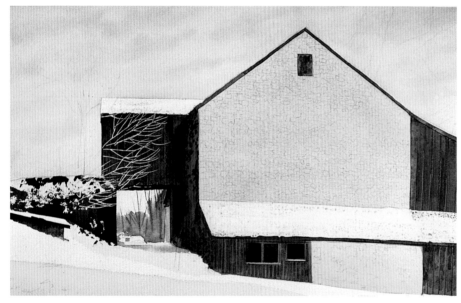

STEP FIVE: **Continue With the Barn**

Detail the wood boards with washes of Payne's Gray and Neutral Tint. Try using an artist's bridge (see facing page) to help with painting straight lines, such as the cracks between the boards.

Use mixes of Neutral Tint, Burnt Sienna and Raw Umber for the background brush colors. Paint in the support wall on the left and the violet of the snow patches with a Neutral Tint/Burnt Umber mix. Continue to detail the sidewall of the barn with a mix of Neutral Tint, Payne's Gray, Raw Umber and Burnt Umber. Use Payne's Gray, Neutral Tint and Raw Umber for the small shed-like structure on the left.

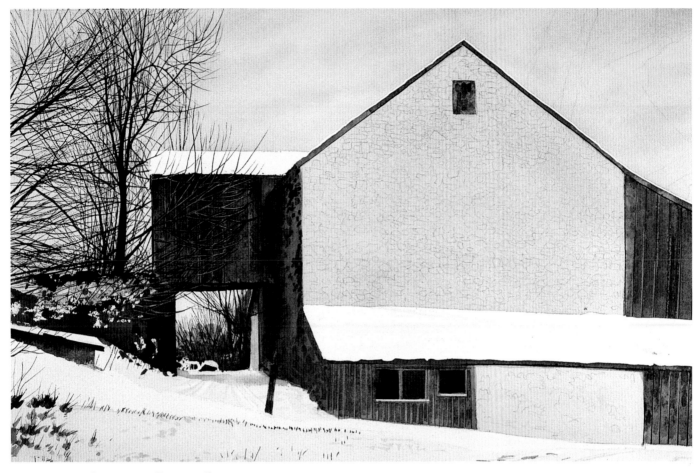

STEP SIX: **Paint the Surrounding Details**

Remove the masking fluid from the trees and roofs. Then paint the trees with a mix of Neutral Tint and Raw Umber, using a no. 3 rigger and no. 0 round sable for the finer branches. Paint the tracks and imprints in the snow with a Phthalocyanine Blue/Payne's Gray mix using a no. 4 round sable. Use the no. 2 round sable and the no. 4 round sable to paint the tufts of grass poking through the foreground snow with Raw Umber. Mix Raw Umber and Neutral Tint to paint the finer grass tips with a no. 0 round sable. (A ruling pen adjusted to the proper line width also works in this instance and provides a line with a slightly different character for variety.)

Painting these areas now gives you a change of pace and a peek toward the finish. There is not always a prescribed best order in which to do a painting. A lot of times it is best to jump around to those areas you feel more comfortable with and work up to other areas that are more problematic. In every painting, I always feel better when I finish some area to my satisfaction, particularly in or around the center of interest. It is a kind of guarantee that the painting is going to be OK.

The Artist's Bridge

Because of my penchant for realism, painting straight lines is a necessary discipline, and an artist's bridge helps me achieve this. A bridge made out of Lucite works best because the Lucite provides a straight, slick and dent-resistant edge that is very easy to keep clean. The 15-inch (38cm) length is practical for the size range of most paintings. Check with your local art supply store for availability.

Line up the bridge exactly parallel to the line you want to paint. Then hold the ferrule of your brush against the bridge's edge, with the brush point just touching the paper. Draw the brush

along the paper's surface. With good-quality brushes, you can paint perfectly straight hairlines in this manner. You can also achieve slightly curved lines by taping a French curve to the bridge and drawing the brush along its edge. Practice first on scrap paper because this can be tricky.

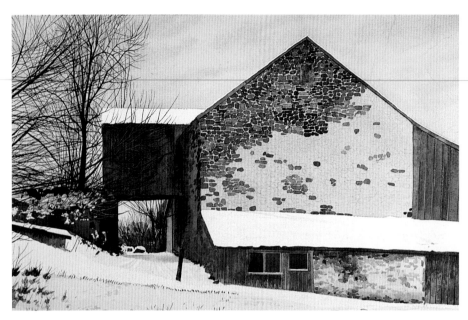

STEP SEVEN: **Lay the Stonework**

To most people, stonework probably looks terribly tedious, but if it is painted in an orderly fashion, it can be downright relaxing and even therapeutic.

The first thing to establish in stonework is the mortar. Numerous glazes have already been applied to this barn, so the mortar value and color should already be established. Mix various stone colors in small quantities. Begin to paint in the stones (Burnt Sienna, Burnt Sienna/Payne's Gray, Yellow Ochre/Payne's Gray, Raw Umber, Payne's Gray). Refer to the photo frequently for ideas on color variation, size, etc. Remember, you want to capture the character of the stonework only; you do not have to do a "portrait" of every stone! Blot the stones with a crumpled paper towel as you paint them to add texture.

To keep your interest, you can play little mind games with yourself. Sometimes I pretend I am a stonemason. My father was a building contractor, and as a young lad, I was fascinated by how the stonemasons fit the stones together. I am sure you have your own life experiences that can be adapted to "laying" stones. Progress is easily measured while painting a stone wall, and when it is complete and looks convincing, your feeling of accomplishment will be worth the effort.

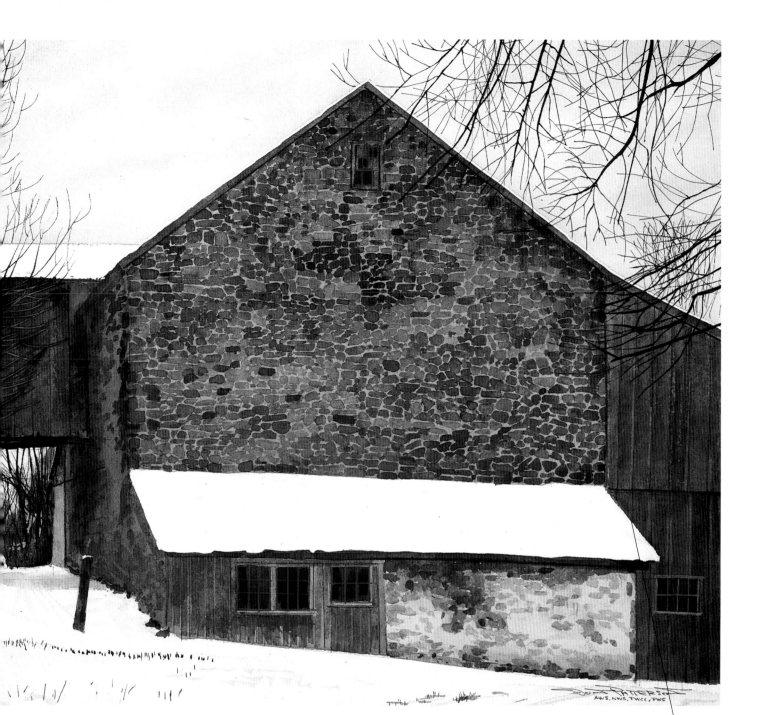

Winter Calm
13" x 20" (33cm x 51cm)
Collection of the artist

Newly defined
roof ending

STEP EIGHT: **Finishing**

After painting the remaining stones, you may find the mortar a little light in value and warmth, so add a wash of Yellow Ochre with a no. 12 round sable. Always use a good-quality soft brush when laying a wash over a painted area so as not to disturb the underlying paint.

Something has been bothering me about this painting from the start, and I now know what it is. The long low roof running across the lower portion of the barn is taking my eye right out of the painting and is spoiling the flow of the composition. To fix this problem, the roof should stop at the end of the masonry wall. From this newly defined roof ending, mask out the wood area from the top of the roofline to the ground with drafting tape. Then wash out this area with a soft natural sponge and clean water, blotting up the color with paper towels. Since the boards are a dark color, it won't matter if you can't remove all the color. Repaint that section again using Payne's Gray and Neutral Tint and add another window for more interest and a further look of authenticity.

Capturing Sunlight

Painting sunlight is more than just light and shadow. It is also about color. This demonstration will show you how to depict the special look of a warm late afternoon sun. Your camera really comes in handy to capture a moment during the increasingly rapid change of light, shadow and color at this time of day.

Paper
300-lb. (640gsm) Arches
 cold-press

Palette
WINSOR & NEWTON
Yellow Ochre
Cadmium Lemon
Cadmium Yellow
Winsor Green
Raw Sienna
Zinc White gouache
Winsor Red

M. GRAHAM & CO.
Quinacridone Rose
Phthalocyanine Blue
Sap Green
Permanent Green Light
Payne's Gray
Quinacridone Violet
Raw Umber
Burnt Sienna
Neutral Tint

Brushes
No. 0 round sable
No. 4 round sable
No. 8 round sable
No. 12 round sable
No. 3 rigger
¾-inch (19mm) oval
2-inch (51mm) flat latex

Other
1-inch drafting tape
Winsor & Newton Art Mask-
 ing Fluid
Small natural sponge
Paper towels
Toothbrush
Ruling pen
Artist's bridge

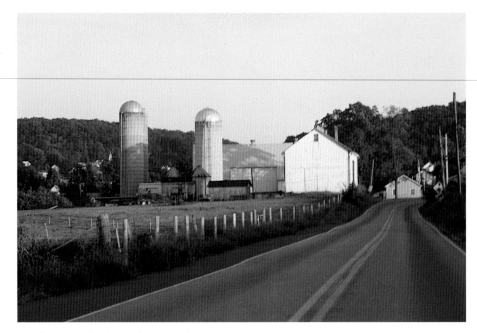

STEP ONE: Study the Reference Photo
This was a hastily taken photo because I was actually sitting in my vehicle in the roadway, and for safety reasons, I wanted to remain in that position just long enough for a quick shot. Upon studying this photo, some major cropping seems to be in order. The two silos overbalance the left side of the photo, and there is too much landscape on the left, so crop approximately one-third off that side. To further balance this composition, crop a bit off the sky, as well as a little off the bottom, and add more landscape to the right side.

To improve this composition even more, increase the height of the remaining silo and move it slightly to the right. Add an Amish buggy to the crest of the road to strengthen the narrative quality. Also, add a pole on the right for additional enhancement of the composition.

STEP TWO: **Paint the Light**

After doing a careful drawing, it is time to paint the "common light." The photo was taken on a late September afternoon when the sun was at a very low angle. The common light is especially warm at this time of day, so use your 2-inch (51mm) flat latex brush to apply a glaze of Yellow Ochre, about 5 percent color intensity, to the whole surface. When it's dry, apply liquid mask to the buildings, fence posts, poles and road signs. Apply more mask with a ruling pen to the weeds and grass along the roadside and field. With a tapping motion of the ruling pen, apply dots of masking fluid to the weeds and road surface for texture.

STEP THREE: **Build the Common Light**

Depicting this kind of light takes a lot of color, so except for the highlight on the metal top of the silo, there will be no whites in this painting. Add four more glazes of about 5 percent color intensity over the entire surface, using, in sequence, Cadmium Lemon, Yellow Ochre, Quinacridone Rose and Phthalocyanine Blue (remember to dry between glazes).

After making sure the final glaze is dry, wet the sky area and brush in random strokes of approximately 30 and 40 percent Phthalocyanine Blue with a ¾-inch (19mm) oval brush. Make sure the paper is flat and that it has a slight even sheen to its surface.

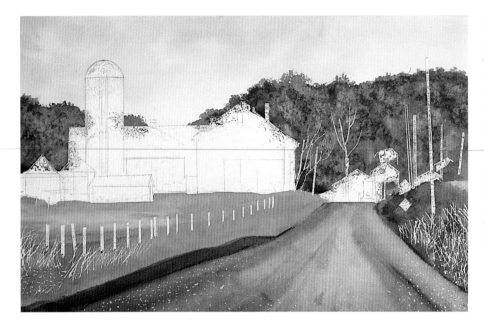

STEP FOUR: **Lay Rich Color**

Block in the background trees with rich values of Sap Green, Permanent Green Light and Winsor Green. For varied texture in the trees, use both a ¾-inch (19mm) oval brush and natural sponges. Paint in the field, on the left, using mostly Sap Green with some Yellow Ochre mixed in. Wait for this to dry, then add more strokes of masking fluid to the field, weeds and grasses. Paint the field on the right using Permanent Green Light mixed with Yellow Ochre, followed by a mix of Winsor Green and Payne's Gray for the darker areas. Wash on Payne's Gray, Quinacridone Violet and Phthalocyanine Blue in the road with a wet-into-wet technique.

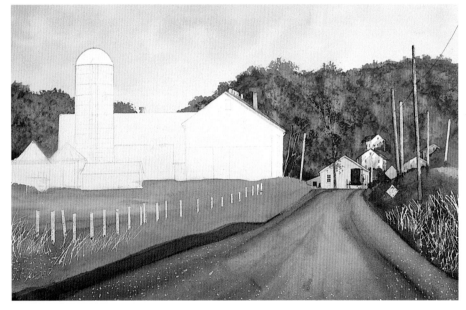

STEP FIVE: **Complete the Background**

After removing the masking fluid from the farm buildings, background trees, houses and poles, complete the background along with the houses, buggy and poles. Use darker values of Permanent Green Light and Winsor Green to paint the tree foliage with both a dry-brush technique and a sponge. Paint the bare tree branches, tree trunks and poles with Raw Umber and Burnt Sienna.

Apply mixes of Phthalocyanine Blue and Payne's Gray to the smallest background houses, using Raw Umber for the roofs and windows. Paint the house directly behind the buggy with Raw Sienna, Phthalocyanine Blue and Neutral Tint. Using a no. 0 round sable brush, apply Zinc White gouache to the gable trim and window.

Paint the roof on the right portion of the large barn and any darker details with Raw Umber. Paint the chimney using Winsor Red and Payne's Gray.

Paint the buggy using Neutral Tint and a Winsor Red/Neutral Tint mix. Paint the little bit of horse showing with Raw Umber. Keep in mind that even though the buggy is quite small, it still must be drawn correctly to be convincing.

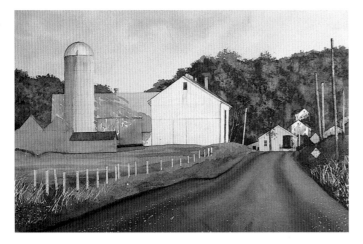

STEP SIX: **Paint the Farm Buildings**

Paint the roof, behind the silo on the large farm building, with a mix of Yellow Ochre and Neutral Tint using a no. 8 round sable. Then paint the cast shadows with a Phthalocyanine Blue/Payne's Gray mix using a ¾-inch (19mm) oval brush.

Use an artist's bridge to aid in adding these details: Lightly indicate the vertical barn boards with Payne's Gray and a no. 4 round sable. Paint the top of the silo with Phthalocyanine Blue, and the "body" of the silo with a wash of Yellow Ochre, another light wash of Neutral Tint followed with a wash of Phthalocyanine Blue on the shadow side. Indicate the silo's texture with Raw Umber.

Paint the roof on the small building in front of the silo with Raw Umber. Add more color to the field on the left using a darker wash of Sap Green, Permanent Green Light and Raw Umber. Using Raw Umber and Winsor Green, paint the darkest accents in the shadow side of the field on the right. Use a wet-into-wet technique and Neutral Tint to strengthen the darker portions of the road surface.

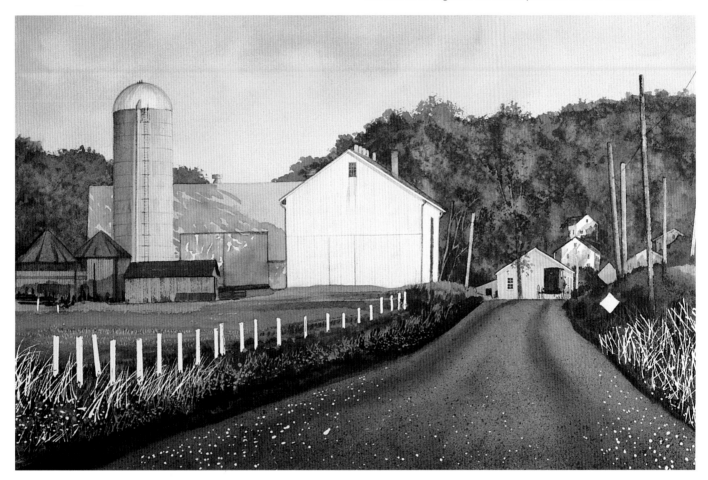

STEP SEVEN: **Finish the Farm Buildings**

Develop the shadow side and top of the silo with Payne's Gray. Paint the finer silo details with Raw Umber. Finish the small building and corncribs with Payne's Gray, Phthalocyanine Blue, Yellow Ochre and Raw Umber. A dry-brush technique, no. 4 round sable, no. 3 rigger and an artist's bridge work best for indicating the small vertical boards and cracks.

Further develop the field by applying a mix of Permanent Green Light and Sap Green. Add a dark mix of Winsor Green and Raw Umber next to the shoulders of the road. Spatter gravel texture on the road using a toothbrush and a dark mix of Neutral Tint. Remove all remaining masking fluid.

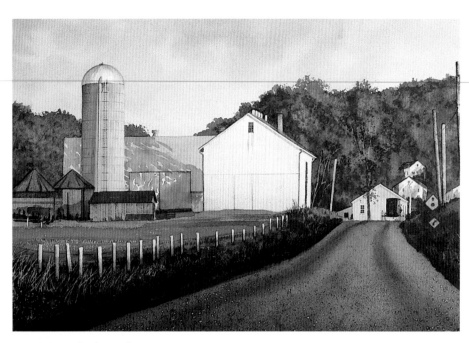

STEP EIGHT: **Final Touches**

With a no. 12 round sable, wash Sap Green over all of the white grasses left by the masking fluid. Paint the fence posts with Yellow Ochre and Raw Sienna. While it's still slightly damp add Phthalocyanine Blue to the bottom portion of the posts as shadow.

Finish the road signs using Cadmium Yellow, Winsor Red, Phthalocyanine Blue and Neutral Tint. Paint in the white spots on the road left by the masking fluid with Raw Umber and Neutral Tint. This works best by applying a darker mix than desired and immediately blotting with a paper towel to the desired value.

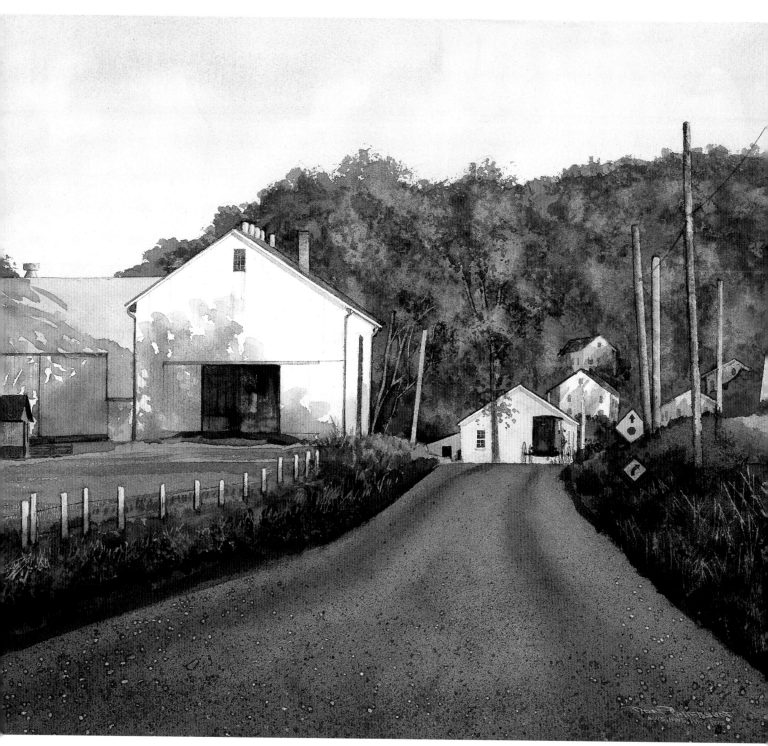

STEP NINE: Revisions

I honestly thought after step eight that this painting was complete, until I looked at it the following morning and immediately saw a problem. The brightly lit portion of the farm buildings sitting smack in the center of the painting brings the whole compositional flow to a standstill.

Breaking up that large expanse of sunlit boards fixes this problem. To do this, open up the barn doors by painting a door track fixture along the break in the boards with Neutral Tint. You can see this break on the reference photo. Then paint cast shadows on both sides of that wing of the barn using a Phthalocyanine Blue/Payne's Gray mix. While the paint is still wet, blot the edges of the shadows lightly to add a softening effect. Paint in the opening between the doors with a wet-into-wet technique using both Raw Umber and Neutral Tint. When this is dry, add some crisp vertical strokes to suggest detail with a mix of Raw Umber and Neutral Tint. Another painting saved at the very end, reminding us once again, this is art, not science.

Country Road
13" x 21" (33cm x 53cm)
Collection of the artist

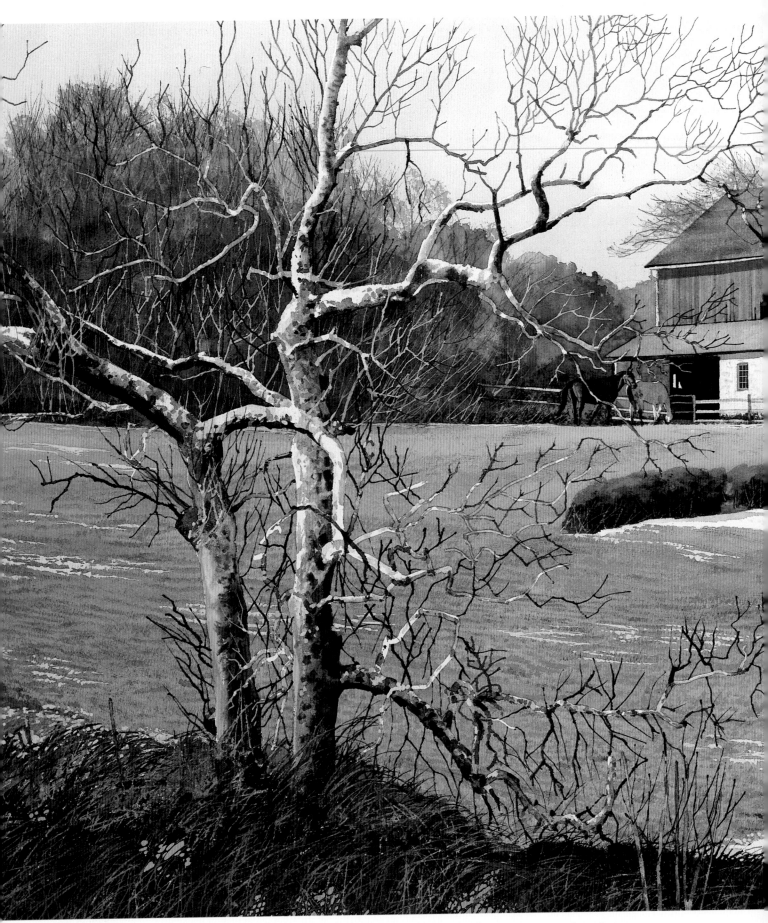

This painting didn't require a rough compositional sketch. The overall scene was composed with my camera, and the size and position of the horses was accomplished with a projector. The addition of snow patches breaks up the color on the pasture, creating additional interest and more feeling of the season.

Winter Pasture
22" x 32" (56cm x 81cm)
Collection of the artist

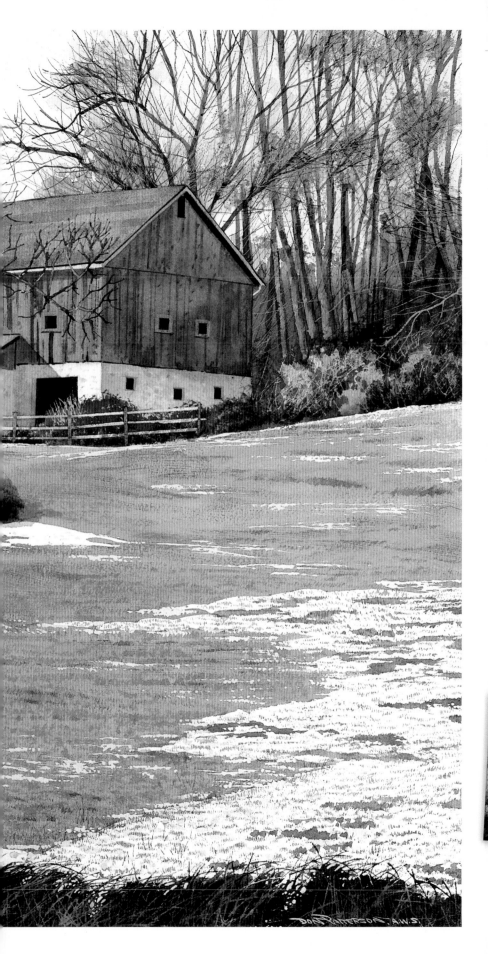

Painting From Two or More Photos

Creating a composition by combining two or more photographs is a good way to take full advantage of the camera. It opens up a whole new avenue to providing full use of your photo reference files. Train yourself to think of the subject matter you find as possible pieces of a larger composition and/or concept. While in the field, there are situations where you can actually begin to create a painting composition by selecting certain elements from the same general location that cannot be photographed together.

This chapter shows you what to look for when combining photos and how easily a composition can be enhanced with the addition of subject matter from another photo.

I was enamored with the twisted sycamore tree because I thought it would help to considerably dramatize this composition. I moved about with my camera, trying to get the tree in the right juxtaposition with the barn. The second reference photo brings life into the composition.

Rules for Combining Photographs

To avoid painting mishaps and wasted time, follow these rules when combining two or more reference photos in a painting.

1. The light source must be from the same direction. You cannot have the sun shining in the same composition from different directions. Ideally, but not absolutely necessary, it should also be at the same angle in the sky.

2. The weather conditions must be the same. Do not combine a cloudy day's light with a sunny day.

3. The season of the year must look the same. The greens of summer should not be combined with the browns of winter.

4. All elements within the picture must be in the same perspective or they will look out of whack one to the other.

5. The relative sizes of elements must be scaled accurately to one another.

If your pictures are taken at the same time, you have more control over following these rules, and problem solving can be reduced considerably. This is not to say you cannot go to your files and select photos taken at different times and combine them. What I am saying is you must keep all of the rules in mind when first making your selections, or you could be setting yourself up for some horrendous problems. See the following pages for tips on how to combine photos that break the rules.

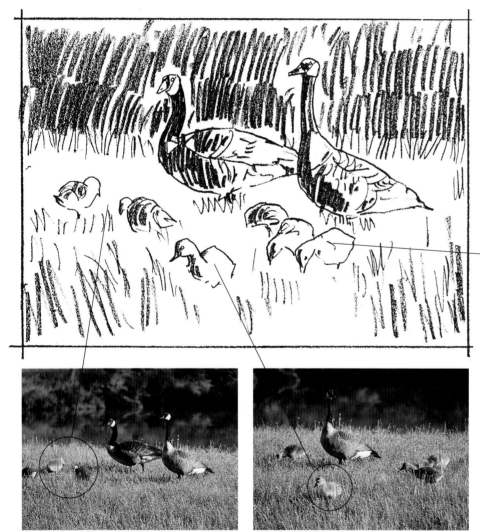

A rough sketch helped me decide the placement for the goslings.

This was the obvious choice for the parents. Notice how they are nicely linked together.

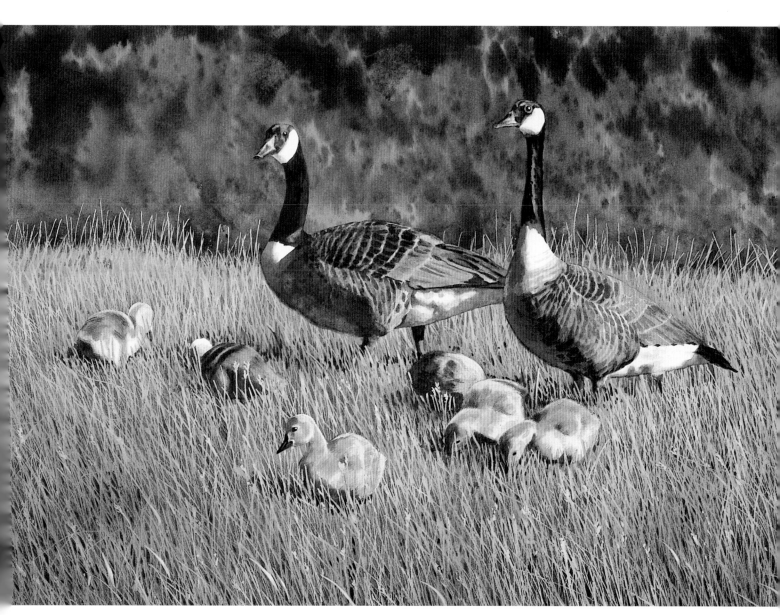

Be Prepared

Some years ago, every spring morning on my early morning bike ride, I would pass this family of Canada geese and think what a charming painting they would make. So one sunny morning I took along a camera with my 75mm–300mm zoom lens and a small bag of bread pieces. I am glad I had the long lens, because when I got closer than ten feet to the goslings the drake would make menacing hissing sounds at me. The bread worked wonders with the goslings, keeping them from moving away. I first concentrated on a good photo of the parents and then took another series of gosling photos to be sure I had enough to work with.

Springtime
20½" x 27½" (52cm x 70cm)
Private collection

Combining Different Light Sources

If you have two reference photos you want to combine and the light is coming from the left in one and the right in the other, you can "flop" (mirror image) one of the photos if the subject will allow it. Just be sure none of the elements in your chosen photo are "right reading," such as lettering or numbering on signs. Right-reading elements often occur in man-made rather than natural subject matter.

Flopping or mirror imaging can be achieved easily with both slides and prints. With slides it is simply a matter of inserting your slide into the projector backward from the usual manner, and be assured color copy machines have the capability to flop both your slides and prints.

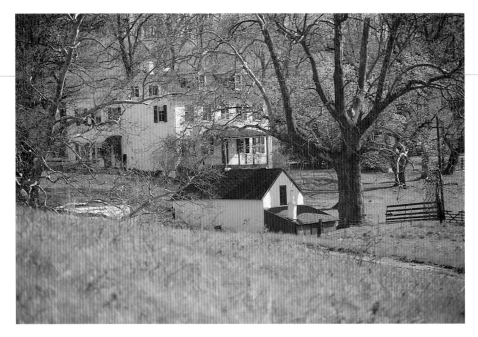

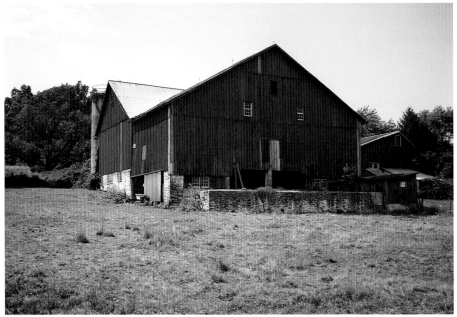

I pulled these two images from my slide files to demonstrate how it is possible to combine photos with different light sources. The top photo shows a light source coming from the right. The bottom photo's light source comes from the left.

This illustration shows the light source on the outbuilding is the reverse of the barn as it is in the reference photos.

Draw a light source directional arrow in the upper left-hand corner that closely represents the light source for the barn. Having this arrow on your drawing will almost certainly prevent you from mixing different light sources within the same composition. It may seem elementary, but I can assure you, it works.

Combining Different Perspectives

Combining photos with different perspectives should be avoided altogether with man-made structures and mechanical objects. Natural forms are possible to combine if the perspectives are only slightly different. The illustration below shows how everything changes with this simple structure when the eye level/horizon line is different.

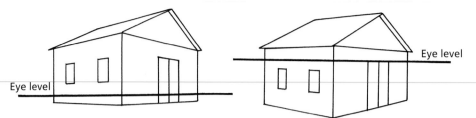

Eye Level/Horizon Line
Perspective itself can become rather involved, but for your needs in combining photographs there is only one basic principle to concern yourself with at all times: the eye level or, as frequently called, the horizon line. They are both the same thing, because the horizon line is your eye level. If all the objects in the photos you select for combining are taken at the same eye level, your perspective problems are greatly simplified. This illustration demonstrates how everything changes with the position of the eye level.

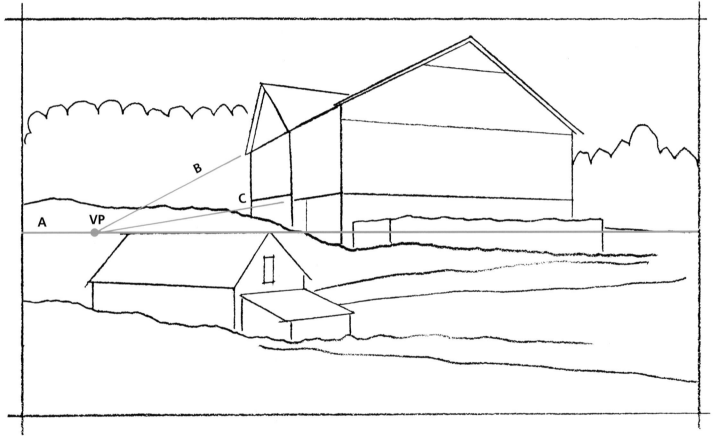

Correct Perspective
To place the buildings in their correct relative perspective, first find the eye level (horizon line) on the barn by drawing two lines (**B**, **C**) that follow the perspective of the barn to their vanishing point (**VP**). Then, draw the eye level (**A**) through that vanishing point. The most level line on the outbuilding appears to be the roofline. Place it on the eye level. The two buildings are now in relative perspective.

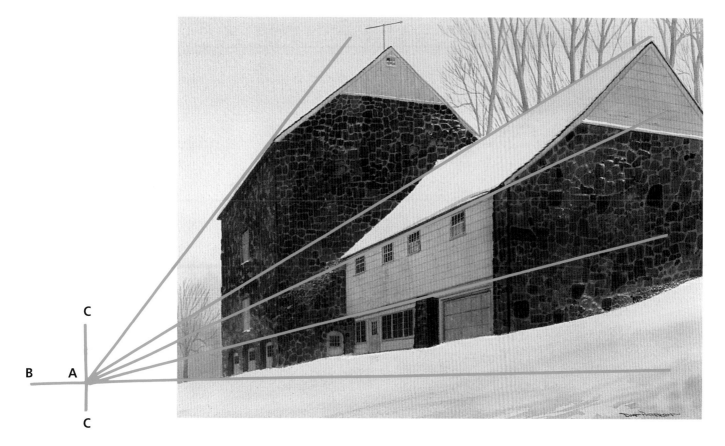

Double-Check Your Perspective

The procedure for checking the correctness of perspective in your drawing is very quick. Draw lines following the angles of the architectural features of your subject as shown. They should all converge to one vanishing point (**A**). This point is the eye level (horizon line, **B**) and the line of sight (**C**). If they do not converge together, something is wrong with the perspective in the drawing.

Tyler's Barn
15" x 20½" (38cm x 52cm)
Collection of Patricia Pennington

Combining Different Seasons

Different seasons are more easily combined if one photo consists of natural organic matter and the other is a manmade object, a human or an animal, providing the two are appropriate together. For example, you would not combine human figures dressed for winter in a spring or summer setting. Nevertheless, changing seasons using two landscape photos can be done.

This reference photo works for its basic composition.

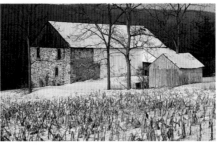

This reference photo works more for the color, feel and foreground detail. It is necessary to flop this photo for the foreground to be compatible with the other photo.

Admittedly, changing the season of a reference photo is not something I do with any regularity, but this sketch demonstrates it can be done if you keep in mind the "rules."

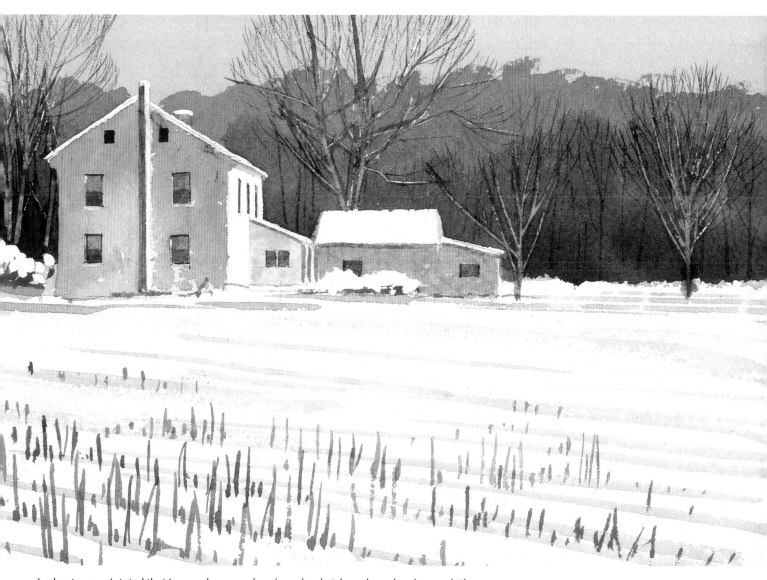

In chapter one, I stated that I never do comprehensive color sketches when planning a painting, and that statement still stands. When I am working with a reference photo that represents what I want to paint or will be combined with another photo or photos that were selected because they follow the "rules," I don't find it necessary to make color sketches. In this case, however, I am attempting to create a scene that doesn't exist, and making a color sketch, as shown here, is a necessary visual to assure my concept will work in the final painting.

Correcting Relative Scale

The moment you focus a camera on a subject you should be thinking about a painting possibility. Ask yourself, "Why am I taking this picture? Do I have an objective in mind? What am I trying to achieve?" The only way a camera will work for you is if you have some direction, some goal you are setting for yourself. Random use of the camera is a waste of film, money and your valuable time. A camera is not a substitute for your creativity.

Quite often you will find a subject where all the ingredients for a complete painting are in one location, but photographing them in correct relative scale is not always possible (with moving subjects, for example). This should not concern you, because the relative scales can be corrected in your studio.

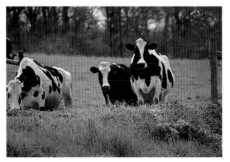

Reference Photos
All the makings of a composition were present in this location. The morning light and slightly elevated position of the cows was excellent, but getting all the cows positioned where I wanted them was not going to just happen by chance.

By taking several shots of different pairs as they approached the crest of the pasture, I knew in all probability something could be put together later in the studio. I was aware the background was too busy and would have to be simplified with some morning mist covering the trees. The bright sun on the foreground grass contrasting with the misty background would add a very appealing look to this painting (see "Painting Grass Texture" demonstration, page 119).

The Rough Sketch
You can answer a lot of questions with a simple rough sketch.

Pasting Together Photocopies
Scaling the reference photos on a photocopier as indicated by the rough sketch and pasting together the black-and-white photocopies assured me this was a workable composition.

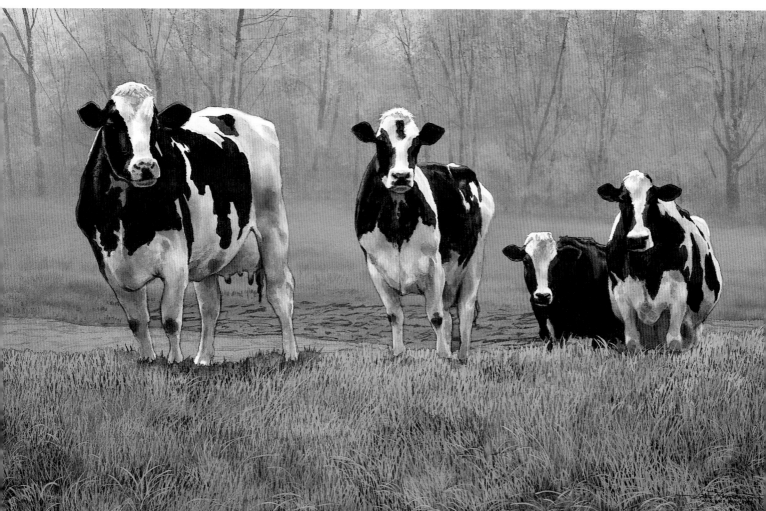

This painting is a perfect example of planning with your camera. I corrected the cows' relative scale to one another with a projector, making the pair on the left larger than the right pair because they are closer to the viewer.

Here's Looking at You, Kid
15½" x 26" (39cm x 66cm)
Collection of Sigmund Balka

Getting the Whole Picture

Make sure when you are out there on location you get the whole picture. Try to develop a concept on the spot and make sure you have all the information it requires. Chances are, you cannot return to the location and find everything the same as it was. Weather conditions change and animal life is hardly ever in the exact location as before.

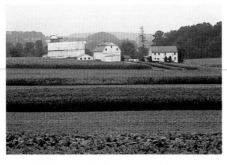

Farm Reference Photo
This was one of those misty, thinly overcast days that has its own special beauty. It was wash-day Monday, as attested by the clothesline.

Farm Boy Reference Photo
This young farm boy was working in the field, but not in the location I wanted him. It was a simple matter to photograph him separately and then position him into the main composition later. The 300mm focal length lens made a very useful photo.

The Rough Sketch
It was just a matter of matching the corn heights in both pictures to scale the boy correctly into the overall composition. I made the sketch to determine his location.

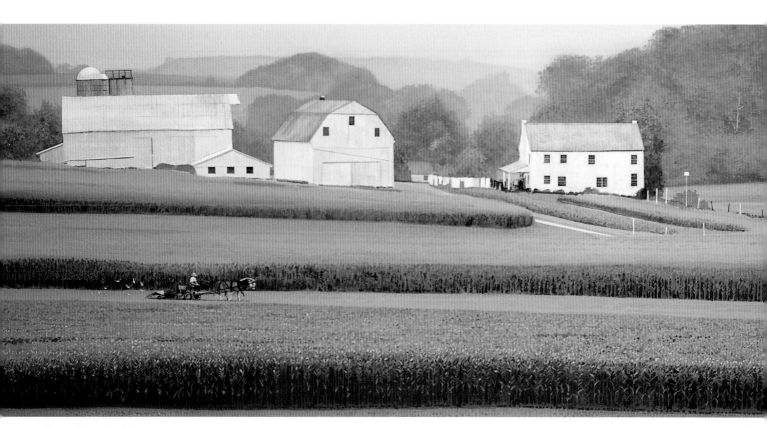

Pennsylvania Fields
13½" x 28" (34cm x 71cm)
Corporate collection

Filling in Insufficient Detail

Another reason for keeping a well-filed film library is so you can efficiently find subject matter when you have a good reference photo that needs some additional details to make a good painting. I started the painting (facing page) with the stone wall and barn siding because I liked the picture. But I felt it needed more of a narrative quality and decided a seagull standing on the wall would be a nice touch. After that, I added the lighthouse to further establish an appropriate environment for the gull.

Lighthouse reference photo

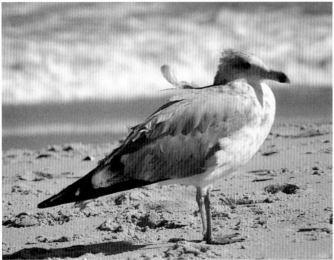

Seagull reference photo

Stone wall reference photo

A rough sketch is all I needed before starting the final painting, because all three reference photos fit together so easily.

I flopped the photo of the seagull and lighthouse in order to confirm the light source coming from the left.

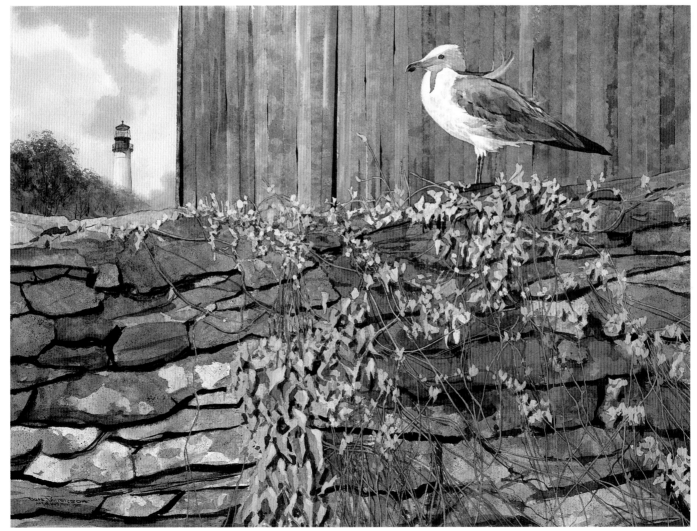

This painting is a total fabrication on my part. I took the three reference photos from totally separate locations and literally years apart in time. I was browsing through my photo files one day and came up with this composition just for the challenge. It reminded me of some things I have seen in Maine.

Sea Breeze
17" x 27" (43cm x 69cm)
Collection of the artist

Understanding Perspective

This painting demonstration exemplifies the value of keeping an organized photo reference file. When I first took the overall reference photo, it was my intention to paint this landscape without adding any other elements. I liked things just as they were, but as I was going through my files looking for ideas for a multiphoto demonstration, this scene came to my attention. Instantly I recalled a picture I had taken several years before of Amish children walking home from school in the wintertime. It took me only a short time to locate the slide because I knew it would be filed under "Lancaster County—Winter." The instant I looked at it, I was certain it was a natural. The perspective is very close to the landscape photo, the season is a match, and the rural environment is tailor-made for the Amish children.

Paper
300-lb. (640gsm) Arches
 cold-press

Palette
WINSOR & NEWTON
Yellow Ochre
Cadmium Lemon
Prussian Green
Hooker's Green
Zinc White gouache
Yellow Ochre gouache
Burnt Sienna gouache
Raw Sienna
Cadmium Yellow
Burnt Umber
Cobalt Blue

M. GRAHAM & CO.
Phthalocyanine Blue
Quinacridone Rose
Payne's Gray
Raw Umber
Quinacridone Violet
Neutral Tint
Burnt Sienna
Quinacridone Red
Prussian Blue

Brushes
No. 0 round sable
No. 2 round sable
No. 3 round sable
No. 4 round sable
No. 8 round sable
No. 1 rigger
No. 3 rigger
¼-inch (6mm) chisel bristle
 brush
2½-inch (64mm) flat latex

Other
1-inch drafting tape
Winsor & Newton Art Masking Fluid
Paper towels
Ruling pen
Artist's bridge
Airbrush

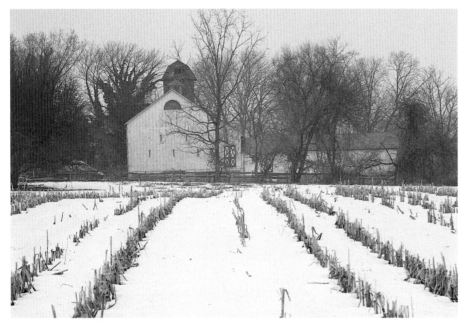

Reference photo of the landscape

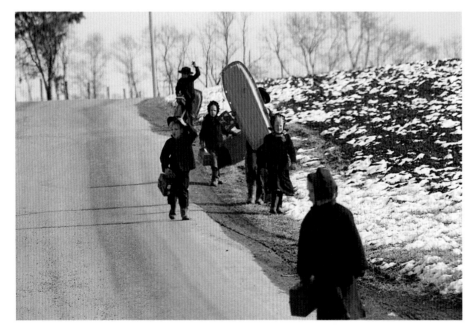

Reference photo of
the children

STEP ONE: **Complete the Drawing**

Placing the children into the composition in the correct relative scale is the first problem to solve. With some knowledge of basic perspective, you will see this is not at all difficult to do.

Always start with the eye level (horizon line **A**) and then locate the line of sight (vanishing point **B**). I knew the eye level should be a little over the fence post height. Based on the receding angles of the corn rows, you can figure the line of sight is lined up near the middle corner of the barn. Keep in mind, because the rows of corn are certainly not precise and the field is not perfectly flat, all of this is an approximation.

Start with what you know in terms of size about your subject. I know that the fence posts in front of the barn are probably close to 5' (152cm) in height, and estimating the ages of the children, my guess is they probably range between 3½' (106cm) to 4' (122cm) in height.

This illustration demonstrates how to determine the correct relative heights of the children. As for the overall composition, crop the top of the image and add to the bottom so that the horizon line will not pass directly through the center of the painting splitting the composition in half.

STEP TWO: **Paint the Common Color**

This was an overcast gray day, so you do not have to mask out any white highlights. There will be no pure whites in this painting. With a 2½-inch (64mm) flat latex brush, lay down three separate glazes over the entire image area using approximately 5 percent color and 80 percent to 90 percent water in the following order: Yellow Ochre, Cadmium Lemon and Phthalocyanine Blue. Make sure the glazes are completely dry between applications.

Note: You may notice only two children are drawn on the watercolor paper at this point. I decided to add two more children later on in step five.

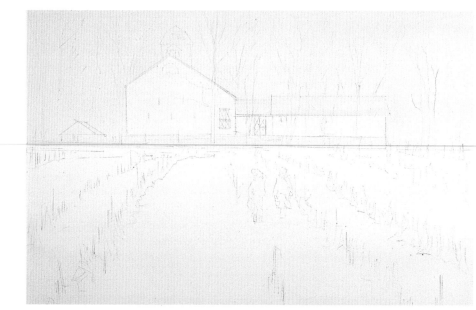

STEP THREE: Distinguish the Sky
Apply a glaze of Quinacridone Rose over the background and sky area above the cornfield. Apply another glaze of Phthalocyanine Blue over the whole painting, blended slightly darker at the bottom. Apply two more glazes of Phthalocyanine Blue, once over the entire painting and once over the sky only. The reason for so many glazes of this one color is to prevent going too far with it. It is better to arrive at the proper color and value in small steps than to overshoot the mark and be forced to wash out an entire area and start over.

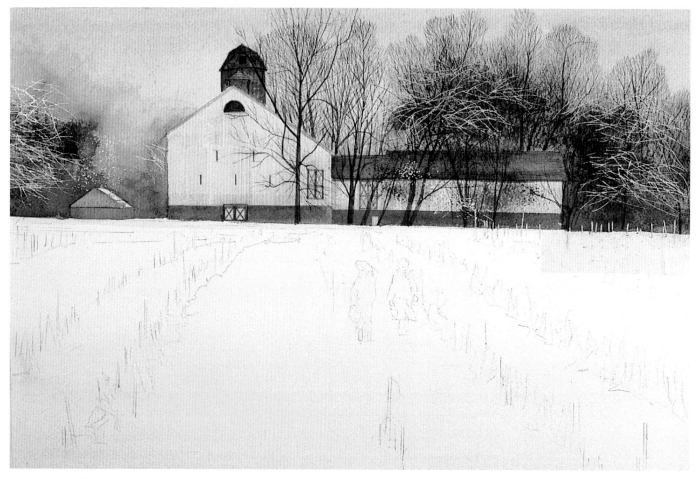

STEP FOUR: Add Background Details
With a ruling pen and masking fluid, draw the lighter-colored fine tree branches directly over the under painting. Follow this with a mix of Phthalocyanine Blue and Payne's Gray over the sky and buildings. Paint the darker tree branches with a no.1 rigger brush using mixes of Payne's Gray and Raw Umber for the darkest branches and Payne's Gray, Phthalocyanine Blue and Quinacridone Violet for the finer end branches.

Paint the building details as follows: barn siding boards—Neutral Tint; barn roof—Payne's Gray and Yellow Ochre; silo—Payne's Gray; silo roof—Payne's Gray and Raw Umber; barn foundation—Raw Umber; door trim—Prussian Green/Hooker's Green; gable window—Payne's Gray/Phthalocyanine Blue with Raw Umber trim; small building (left)—Burnt Sienna and Payne's Gray; all dark linear details—Neutral Tint.

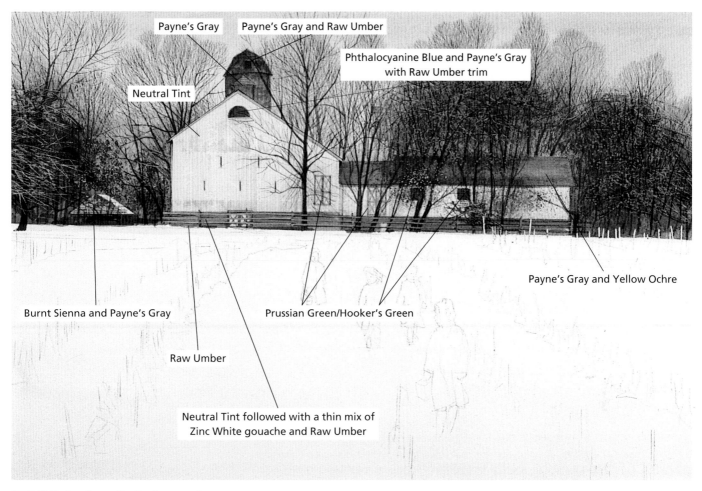

Payne's Gray

Payne's Gray and Raw Umber

Phthalocyanine Blue and Payne's Gray
with Raw Umber trim

Neutral Tint

Payne's Gray and Yellow Ochre

Burnt Sienna and Payne's Gray

Prussian Green/Hooker's Green

Raw Umber

Neutral Tint followed with a thin mix of
Zinc White gouache and Raw Umber

STEP FIVE: **Continue the Background**

Continue painting the trees with the no. 1 rigger, no. 3 rigger and no. 3 round sable. Next, remove the masking fluid from the remaining branches and paint them with a mix of Raw Umber and Payne's Gray. Brush a mix of Payne's Gray and Raw Umber over the light tree branches left by the masking fluid. This method works best if a darker than desired value of color is initially applied and then blotted with a paper towel as you go along. Then with a creamy mix of Zinc White gouache, Yellow Ochre gouache and Burnt Sienna gouache in a ruling pen adjusted to a 1mm-thick line, begin to tap on the leaves still remaining on the trees. (Experiment on a scrap piece of paper before trying this technique on your painting.)

With a no. 4 round sable, paint the fence in a dark value of Neutral Tint followed with a thin mix of Zinc White gouache and Raw Umber, leaving some dark accents around the posts and rails. Paint the remaining two windows on the right with Payne's Gray and Raw Umber using a no. 4 round sable. (Also at this point, I decided to add two more children for compositional improvement and interest. Refer to the reference photo and illustration in step one).

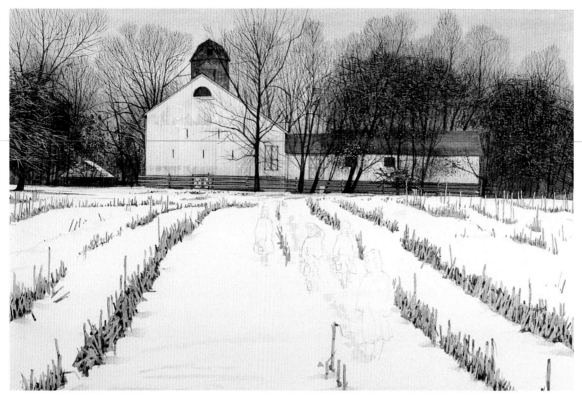

STEP SIX: Paint the Cornfield
With a ruling pen, draw masking fluid over the lighter-colored cornstalks. Paint the remaining stalks with mixes of Yellow Ochre, Raw Sienna, Burnt Umber and Payne's Gray using a no. 4 round sable. Remove the masking fluid and paint in the lighter stalks with Yellow Ochre. Use Payne's Gray to paint the children's footprints. Use a no. 8 round sable to paint the shadows on the snow from the cornstalks.

Paint the Children in the Field

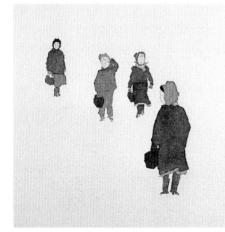

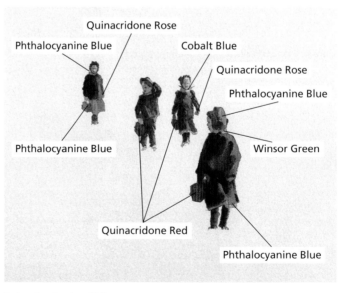

Quinacridone Rose
Phthalocyanine Blue
Cobalt Blue
Quinacridone Rose
Phthalocyanine Blue
Winsor Green
Phthalocyanine Blue
Quinacridone Red
Phthalocyanine Blue

Paint the Base Colors
Paint the faces with a mix of Cadmium Yellow and Quinacridone Red. Paint the blond hair with Raw Sienna and the dark hair with Raw Umber. Paint the clothing as follows: Phthalocyanine Blue and Prussian Blue for the skirts and one bonnet; Phthalocyanine Blue for one lunch box; Quinacridone Red for remaining three lunch boxes; Cobalt Blue for middle girl's scarf and skirt; Quinacridone Rose for both the left and middle girls' gloves; Neutral Tint for darkest clothing and boots.

Paint the Darker Values
Paint the darker values of each color on both the clothing and the lunch boxes. Soften the edges with a dampened ¼-inch (6mm) chisel bristle brush.

Using a no. 2 round sable brush, paint the shadow portions of the faces with a mix of Cadmium Yellow, Quinacridone Red and Quinacridone Violet. Using a no. 0 round sable, indicate the eyes with Neutral Tint and the mouths with Quinacridone Red. Accent blond hair with Raw Umber.

STEP SEVEN: Add the Children and Final Touches

After painting in the children (see steps on facing page), paint over the cornstalks with a light wash of Payne's Gray because they look a little too intense. With a slightly lighter color value of gouache than in step five, complete the leaves on the trees. With an airbrush add a very subtle gradation to the foreground snow and across the lower portion of the background (above the ground level) and buildings with a mix of Phthalocyanine Blue and Quinacridone Violet.

School Days
12" x 18" (30cm x 46cm)
Collection of the artist

Matching Relative Sizes

This demonstration will show you what to look for when selecting multiple photos from your reference files for one painting. We will deal with how to logically create a composition in proper perspective and correct relative scale, along with getting it onto your watercolor paper.

This photograph of an Amish farm will work well for the painting's middle ground and background.

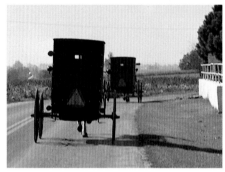

Since this is an Amish farm, buggies and cows are an appropriate addition. I went through my buggy and cow slide files looking for images that would, for the most part, fit into the basic set of rules for combining photographs. The two buggies shown look like a perfect fit. The direction of the light is close to perfect and so is the perspective. This picture even has the road curving to the right, making it easy to connect with the road passing in front of the farm in the background photo.

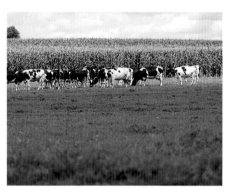

These cows will add life to the painting's middle ground.

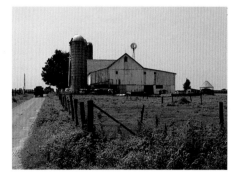

This photo provides fencing detail and foreground foliage.

Paper
300-lb. (640gsm) Arches
 cold-press

Palette
WINSOR & NEWTON
Yellow Ochre
Olive Green
Hooker's Green
Zinc White gouache
Red Ochre gouache
Primary Blue gouache
Spectrum Violet gouache
Winsor Red

M. GRAHAM & CO.
Quinacridone Rose
Phthalocyanine Blue
Payne's Gray
Raw Umber
Quinacridone Violet
Sap Green
Burnt Sienna
Neutral Tint

Brushes
No. 0 round sable
No. 2 round sable
No. 4 round sable
No. 3 rigger
¾-inch (19mm) oval
1-inch (25mm) ox-hair chisel
1-inch (25mm) oval
¼-inch (6mm) flat bristle
2½-inch (64mm) flat latex

Other
1-inch (25mm) drafting tape
Winsor & Newton Art Masking Fluid
Small natural sponge
Paper towels
Ruling pen
Artist's bridge

Sketch

At this point, I started to make very rough sketches to get a feel for the whole composition. During this sketch stage I determined to have an elevated or almost eye-level pasture for the cows, rather than the gully depicted in the photo. It would be better to keep everything basically on the same eye level to eliminate perspective problems, and I also preferred to have the pasture very foreshortened, therefore providing a quick progression up the road with the buggies, over to the cows and on back to the farm buildings.

Relative Scale

In order to calculate relative sizes, start with what you know and progress from there. I know from personal observation and looking at photographs, a buggy's rear wheels are more than waist high on the average man. I also know the same man is about a head taller than the shoulders of a cow. Fence posts around pastures are usually five feet high. As you can see, we are dealing only with approximate comparisons.

Make Photocopies

First, I had my slides enlarged and converted to color copies on 8½" x 11" (22cm x 28cm) paper. The goal is to make the different parts of the painting "look right" one to the other. By using these comparisons, it is possible to calculate the percentages for enlargement or reduction and bring the pictorial elements in all four of the reference prints into relative scale.

I then roughly scissored the prints and placed them together into a fairly accurate facsimile of the composition and made a photocopy to see if the sizes fit together.

STEP ONE: Complete the Drawing

From the photocopy make the grid drawing. The reason for the grid is to enable me to project the four slides, one at a time, onto my watercolor paper in their correct relative scale and positions using the same grid, only enlarged on the watercolor paper to the painting size. Do not actually draw the grid over your watercolor paper, but merely indicate the grid lines with marks along the four sides. Then by holding a yardstick against the paper from one grid line mark to its opposite on the other side while projecting the slides, you can easily locate where the grid lines should be in the image area of the painting. Using this method eliminated the need to make another drawing to the painting size and then transferring it to the watercolor paper.

Checking Relative Scale

I first sized the man to the rear wheel on the foreground buggy and then moved him to the right where the fence is to be located. I sized the fence post that is on the same plane as the man to his shoulder height (approximately five feet). I then sized the man to the second buggy and moved him to the right on the same plane as the cows. Making the cow's shoulder height the same as the man's brings them into relative scale with the second buggy.

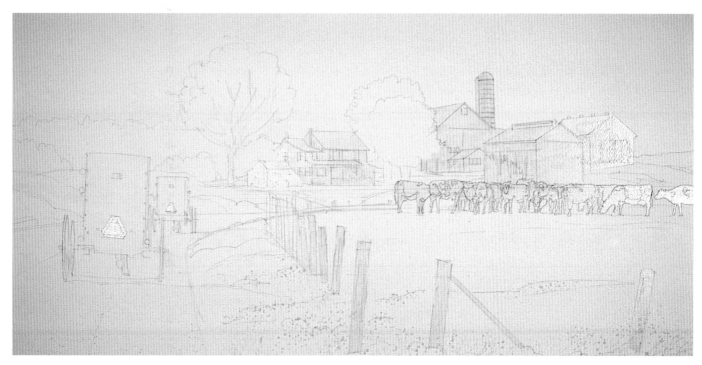

STEP TWO: **Paint the Common Light**
With the drawing complete, cover the buggies' safety reflectors, cows, farm buildings and fence posts with masking fluid. Also use masking fluid on the grasses, weeds and roadway gravel. Then apply three separate glazes of Yellow Ochre, Quinacridone Rose and Phthalocyanine Blue in approximately 5 percent color and 90 percent water over the entire surface using a 2½-inch (64mm) flat latex brush.

STEP THREE: **Add the Sky**
After wetting the sky area with clear water, apply a 10 percent mix of Quinacridone Rose blended toward the horizon. This should be done with your table only slightly tilted.

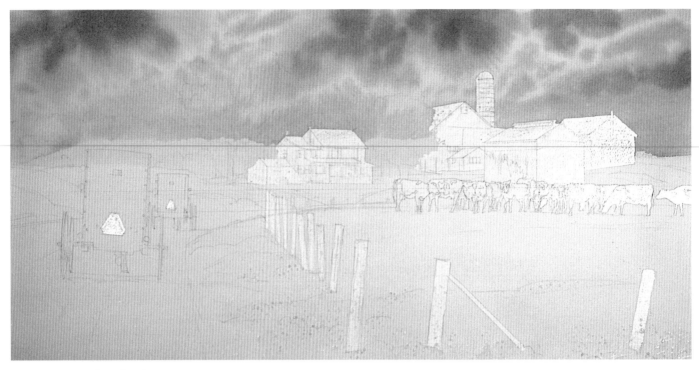

STEP FOUR: **Develop the Sky**

When the surface is dry, wet the sky area again. With your table flat and making sure there is an even sheen to the paper, use a 1-inch (25mm) oval brush to stroke in areas of Phthalocyanine Blue in values of approximately 30 percent and 60 percent. When this is dry, wet the paper again and paint the underside of the clouds with a mix of Quinacridone Rose and Payne's Gray in values of 30 percent and 50 percent.

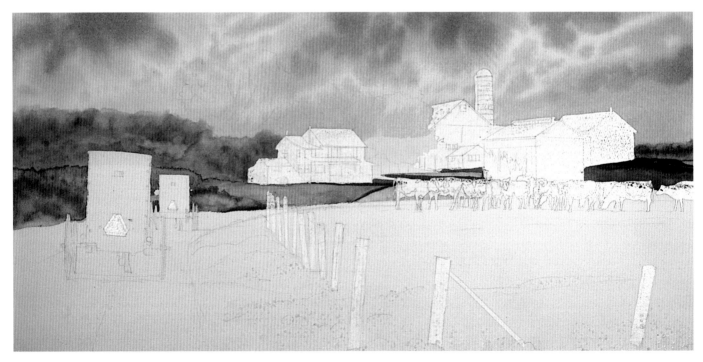

STEP FIVE: **Begin the Background**

Paint in the far background using a ¾-inch (19mm) oval brush. Looking at the photo, paint in Raw Umber, Quinacridone Violet and Payne's Gray for the distant background and Yellow Ochre, Sap Green, Burnt Sienna and Raw Umber for the closer background.

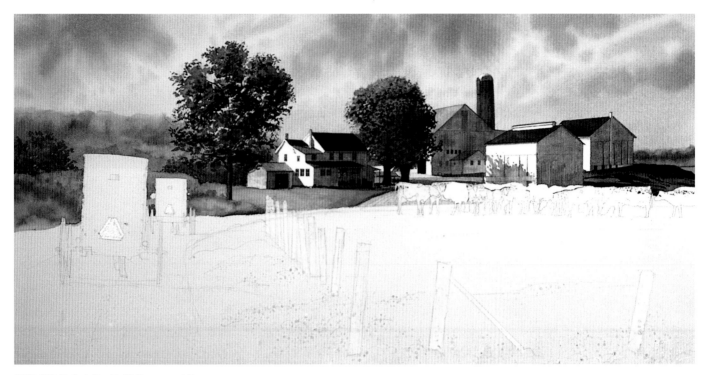

STEP SIX: **Paint the Buildings and Trees**

After removing the masking fluid from the buildings, paint the shadow sides of the buildings with a mix of Phthalocyanine Blue and Payne's Gray. Paint the chimneys and far left wall and roof of house (garage) with mixes of Quinacridone Rose and a touch of Payne's Gray. Paint the house rooftops first with Payne's Gray followed with a mix of Raw Umber and Payne's Gray for the shadow portions using a no. 4 round sable brush. Paint the larger barn's roof with a mix of Quinacridone Rose and Payne's Gray. The two smaller barn roofs are Neutral Tint and Yellow Ochre.

Paint the entire silo with Phthalocyanine Blue and Payne's Gray and then paint the column of the silo with Burnt Sienna blended darker to the right side. Do not try to lay down perfectly smooth washes in any of this. The intent should be to depict the mottled and textural surfaces of a weathered farm. Paint the barn siding boards with Payne's Gray using a no. 2 round sable. With a no. 3 rigger and an artist's bridge, indicate the cracks between the boards. Add the windows and other details with a dark mix of Neutral Tint using a no. 0 round sable and a no. 2 round sable.

Render the trees in two values mixed from Sap Green, Olive Green, Hooker's Green and Payne's Gray using a no. 4 round sable brush.

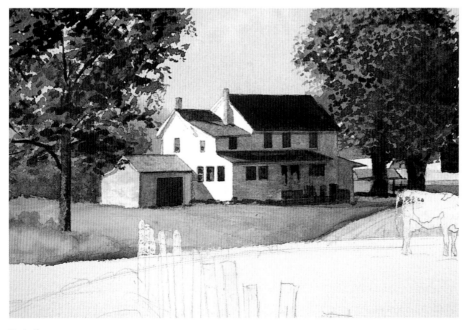

Detail

There are times when perfectly smooth washes are out of character for the subject.

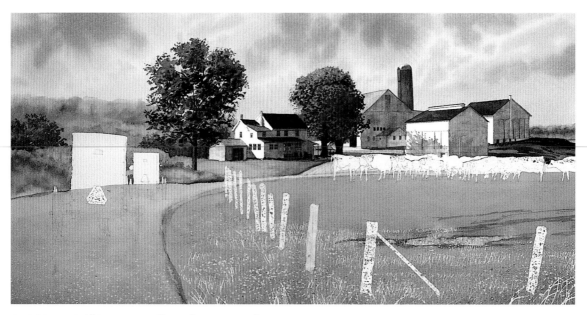

STEP SEVEN: Add House Details and Foreground
Using a no. 0 round sable, paint window mullions, reflections and frames with a thin mix of
Payne's Gray and Zinc White gouache. Clean up the cornice on the house with Zinc White
gouache. (Notice, in the foreground, I cut off the bottom of the center fence post to align with
other posts paralleling the road.) Add a wash of Sap Green over the pasture using a 1-inch (25mm)
ox-hair chisel brush. Draw more texture and grass blades with masking fluid using a ruling pen.
Mix the dirt patches from Red Ochre gouache and Burnt Sienna. Cover the road with a mix of
Quinacridone Rose, Quinacridone Violet and Payne's Gray using a ¾-inch (19mm) oval brush.

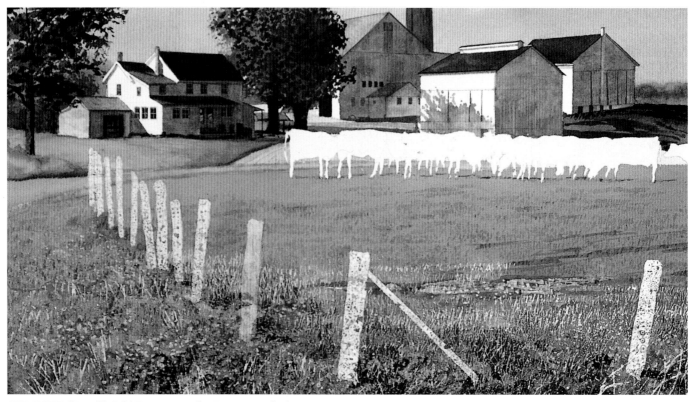

STEP EIGHT: (Detail) Add Texture to the Foreground
With a mix of Sap Green and Olive Green, add more texture to the top surface of the pasture,
working toward the cows, with short strokes of a no. 2 round sable brush. With a ruling pen and
masking fluid, add more grass strokes to the foreground pasture and dots to the road. Then
wash slightly darker values of Sap Green/Olive Green over the same area.

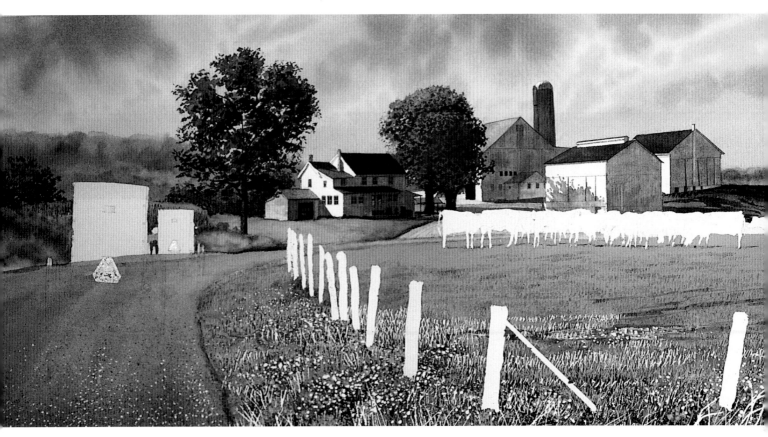

STEP NINE: Continue the Foreground

Remove the masking fluid from the road and pasture. Using a wet-into-wet technique, paint darker values of Quinacridone Rose, Quinacridone Violet and Payne's Gray to the road with a ¾-inch (19mm) oval brush.

STEP TEN: **Finish the Foreground**

Add a wash of Sap Green over the near grassy areas, and continue with more short strokes of texture to the top surface of the pasture. Use the road colors to paint in the white dots left by the masking fluid on the road. Paint the fence posts with Payne's Gray, Raw Umber, Burnt Sienna and Neutral Tint. Paint the buggies with Neutral Tint and Payne's Gray. Paint the small highlights on the buggies with Zinc White gouache and a Zinc White gouache/Payne's Gray mix. Use Winsor Red, Quinacridone Rose and Neutral Tint for the safety reflectors and taillights. Paint the horses' legs and hooves with Neutral Tint and Raw Umber with Zinc White gouache highlights.

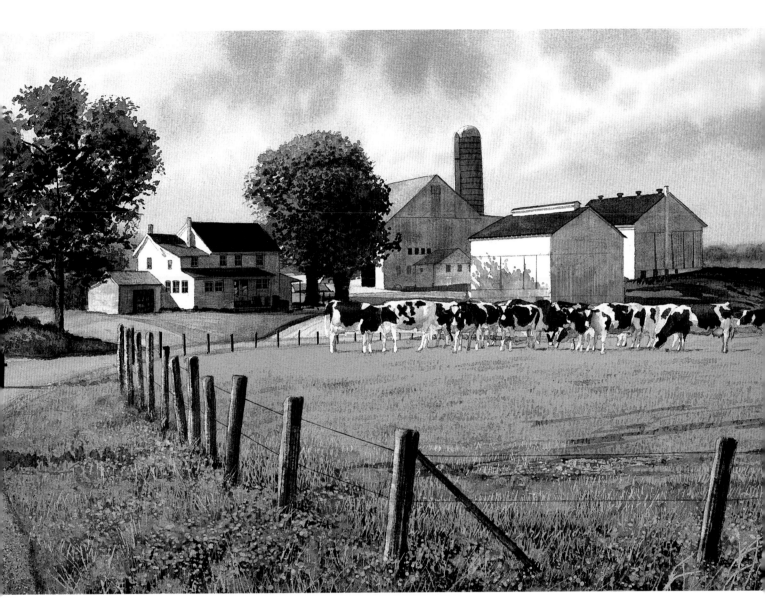

STEP ELEVEN: Add the Cows and Final Touches

You will find painting a group of black-and-white cows is a little mind-boggling because it becomes very difficult in some places to know where one cow ends and another begins. First using Payne's Gray and Phthalocyanine Blue, model the light and shadow areas of the cows. Soften the edges of the shadow areas with a ¼" (6mm) bristle brush. Use touches of pale Quinacridone Rose on the udders. Study the reference photo very carefully. Use Neutral Tint to paint your way through the maze of black-and-white patterns.

After finishing the cows, start on the flowers by mixing two small quantities of gouache, with a creamy consistency, using Zinc White gouache with Primary Blue gouache and a touch of Spectrum Violet gouache in two values. Using a ruling pen with the points set approximately 1mm apart, apply the flowers with a tapping motion. Be advised to test and practice this technique on scrap paper before attempting it on your painting.

Amish World
14" x 18" (36cm x 46cm)
Collection of the artist

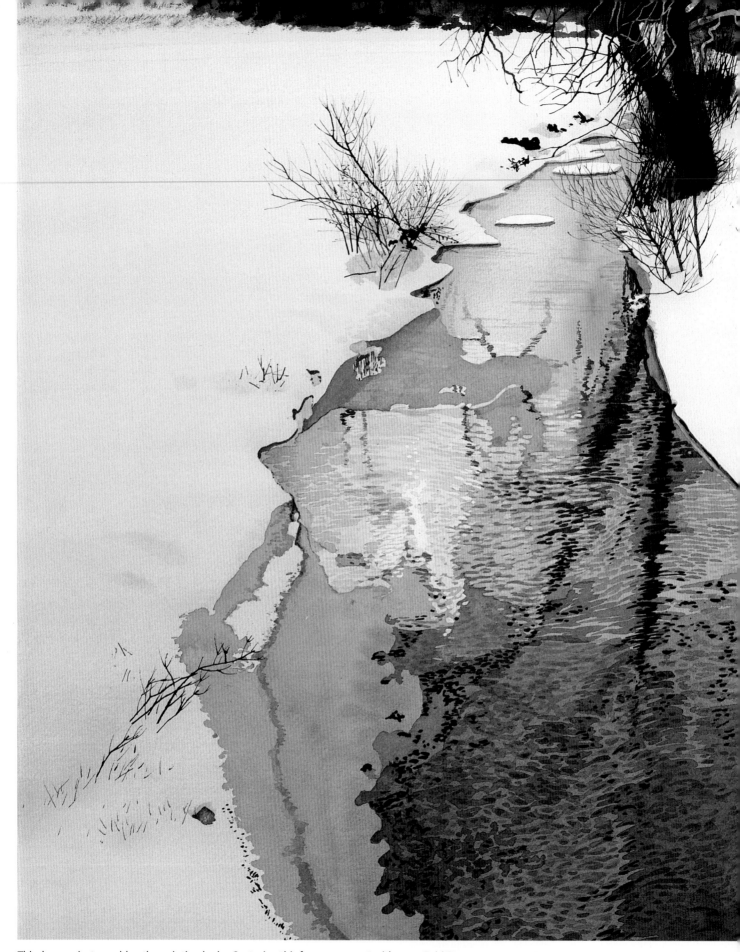

This day was just as cold as the painting looks. Capturing this frozen moment with my camera was my only choice.

Cold Stream
18½" x 24¾" (47cm x 63cm)
Collection of Vihram Reddi

Creating Exciting Concepts and Compositions

For any painting to be completely successful there has to be more than just a faithful and skillful rendering by the artist. It is the artist's responsibility to bring something more to his or her work. It has been said before, "There is no boring subject matter, only boring art." So when you venture forth with your camera in search of something exciting to paint, remember much of that excitement comes from within yourself.

One objective in this chapter is to increase your awareness that exciting things to paint are all around you. Most times it takes only a little imagination, a small addition, better use of light or a slightly different perspective to make the ordinary special and compelling. The opportunities are endless, and when they present themselves it is your job to recognize them. The good news is, it is not all that difficult.

On this bitter cold afternoon, the dim low-lying sun was positioned perfectly to reflect off this partially frozen stream. Credit the light for creating this very special winter landscape and my camera for recording the moment.

Don Patterson, AWS

The Power of Light and Shadow

For sheer visual impact, it is hard to beat bright sunlight and strong cast shadows. The full value range and dramatic patterns brought about by the sun will turn almost any subject into a veritable feast of colorful lights and darks. Cloudy, misty or foggy days are monochromatic and moody, and they certainly provide an essential part of an artist's "diet," but nothing lifts the spirit like clear skies and bright sunlight.

This is an example of a captivating light-and-shadow subject that never would have happened without the camera. I cannot imagine sitting on this fenced bather's walkway to the beach on blistering hot sand, while trying to make an accurate drawing of this sand fence, not to mention the ever-changing shadows.

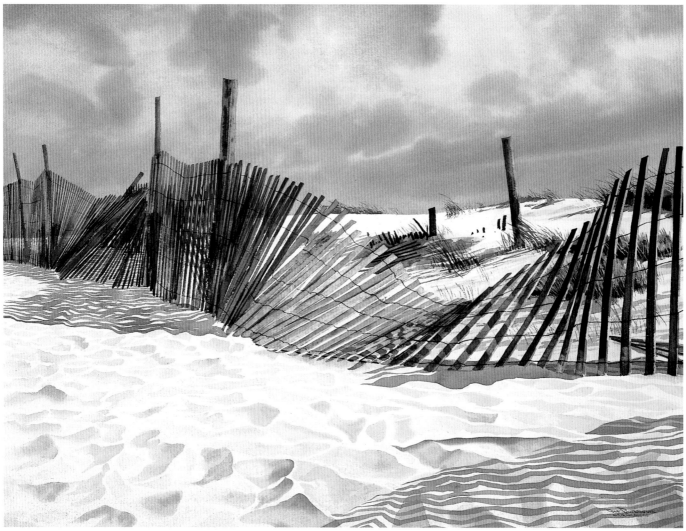

Windswept
20" x 27½" (51cm x 70cm)
Collection of Steven Patterson

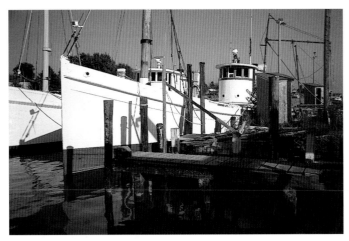

Strong Light Forms the Abstract

The strong sunlight brings all the excitement to this scene. It turns the boats' hulls into the whitest whites, bringing about the wonderful contrast of the dark pilings and their cast shadows. I particularly love the deep shadows in the foreground. When I squinted my eyes, all I could think of was the powerful abstract quality provided by the sun.

This sketch serves to show the abstract pattern formed from the light and shadow in this composition.

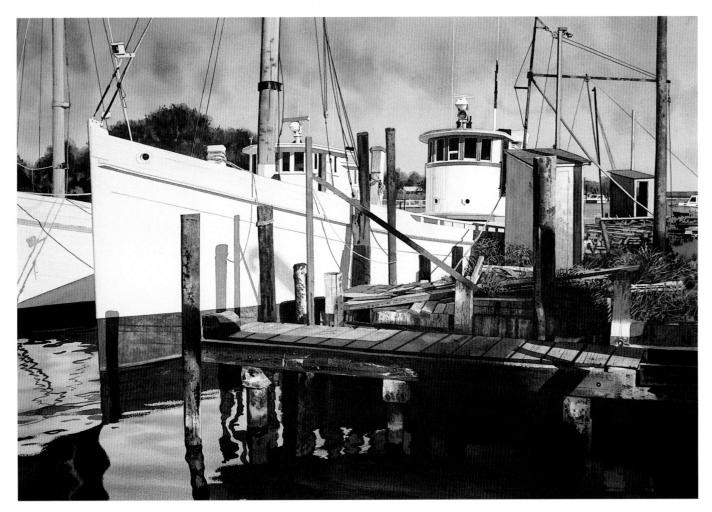

Out of Service
26" x 38" (66cm x 97cm)
Collection of Paul Patterson

Let Color Set the Mood

My priority order when planning a painting is the following:

1. Concept/composition
2. Drawing
3. Execution
4. Color

Making color last on my list doesn't mean it's not important, it means it is the least demanding of my four priorities. Without a good concept/composition, nothing else really matters. Color is extremely subjective, good drawing is not. Having the ability to execute your ideas on paper is not debatable.

The fun and beauty of color is that you are not locked into so many rules and disciplines. With color you have freedom to express yourself, even in representational art. The demonstration on page 111 shows you how to freely use color without relying on reference photos.

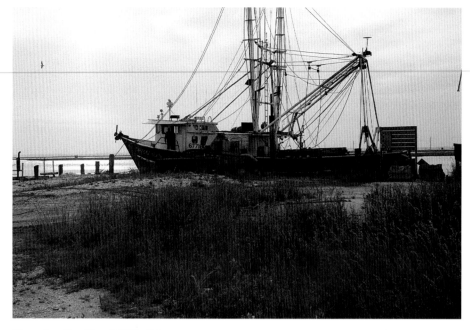

Changing the Mood With Color
It is not all that difficult to use color to change the mood in your painting. Here is an example of using the reference photo only for the drawing and composition and relying on imagination and memory for the color.

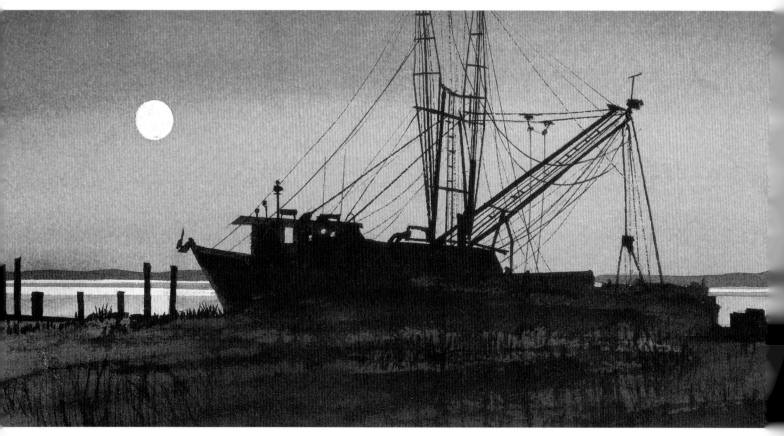

Color sketch with color gathered from my imagination

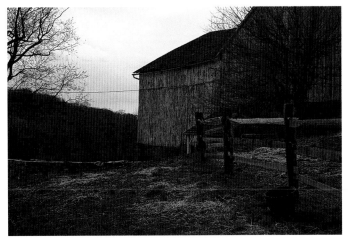

I used this reference photo for the landscape and composition.

I used this reference photo for its misty-light quality.

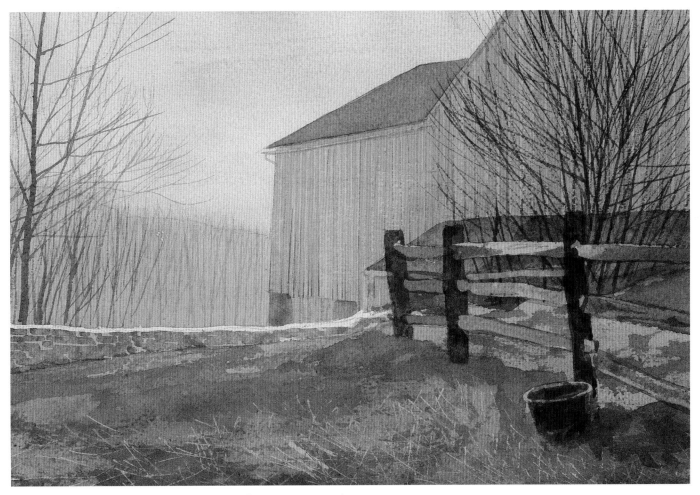

Color sketch with color and composition gathered from two separate photos

Let Color Set the Mood

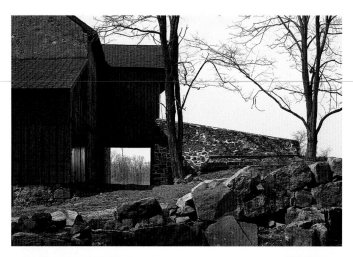

Reference photo for composition

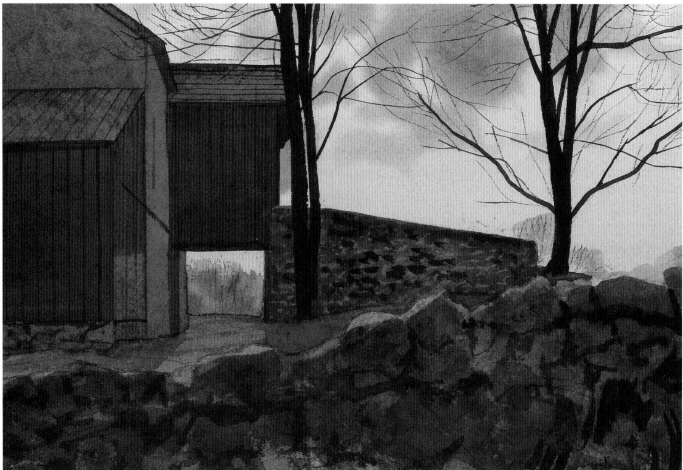

This color sketch demonstrates how easily a bright sunny morning photo can be transformed into a twilight painting. A good composition comes first, and color is secondary and can totally change the mood.

Painting Color From Your Memory

Paper	Brushes
300-lb. (640gsm)	No. 4 round sable
Arches cold-press	No. 12 round sable
	¾-inch (19mm) oval
Palette	
WINSOR & NEWTON	**Other**
Yellow Ochre	1-inch (25mm) draft-
	ing tape
M. GRAHAM & CO.	Paper towels
Quinacridone Rose	Artist's bridge
Phthalocyanine	Airbrush
Blue	
Payne's Gray	

Earlier in this book I stated how you should paint outdoors as much as you can because it is important for you to observe nature firsthand. Painting on location is unequaled in storing a lifetime of nature's images in your memory. As time goes by, you gather a huge library of these images in your memory, and this can be an inestimable help when working from photographs.

Even when you are not actually painting, train yourself to be constantly observing what is around you at all times. This color sketch comes from just such a memory. It is an example of using a reference photo for the drawing and composition, and relying on memory and imagination for the color.

STEP ONE: Paint the Common Color
Using a no. 12 round sable, start with three glazes: Yellow Ochre, Quinacridone Rose and Phthalocyanine Blue. When this is dry, wet the entire surface. With a no. 12 round sable, blend a wash of Quinacridone Rose from midway down to the bottom. Follow this with a 15 percent to 20 percent glaze of Yellow Ochre.

STEP TWO: Wet-Into-Wet Color
Wet the entire surface using a no. 12 round sable. When the surface reaches an even sheen, apply Phthalocyanine Blue across the top section, Quinacridone Rose across the middle section and Yellow Ochre across the bottom section.

STEP THREE: Painting the Clouds
Wet the entire surface and add a wash of Quinacridone Rose to the whole area except for the blue sky at the top. While it's still wet, paint in dark clouds with Payne's Gray using a ¾-inch (19mm) oval brush. Blot the top middle section of the clouds to simulate the sun hidden behind this area.

STEP FOUR: Finishing
With a no. 4 round sable, paint in the ground and trees with Payne's Gray using a wet-into-wet technique. When it's dry, with an airbrush and Quinacridone Rose, deepen the color on the underside of the clouds blended toward the bottom.

Making the Mundane a Winner

The key to a successful painting is certainly a lot more than just drawing and painting. The key is showing a subject within a composition that offers a fresh and/or unique point of view, transforming the ordinary to the extraordinary.

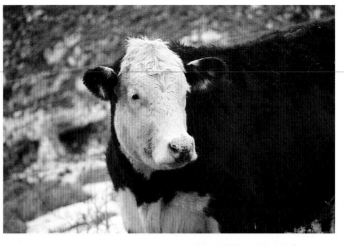

This photo isn't awe-inspiring, and yet I knew as I was taking it that it was an excellent chance for a better-than-ordinary painting. This picture was taken on a very cold winter day, but I was unable to capture the cow's breath with my camera when she was in a position I liked. I had my concept, and that is all that mattered.

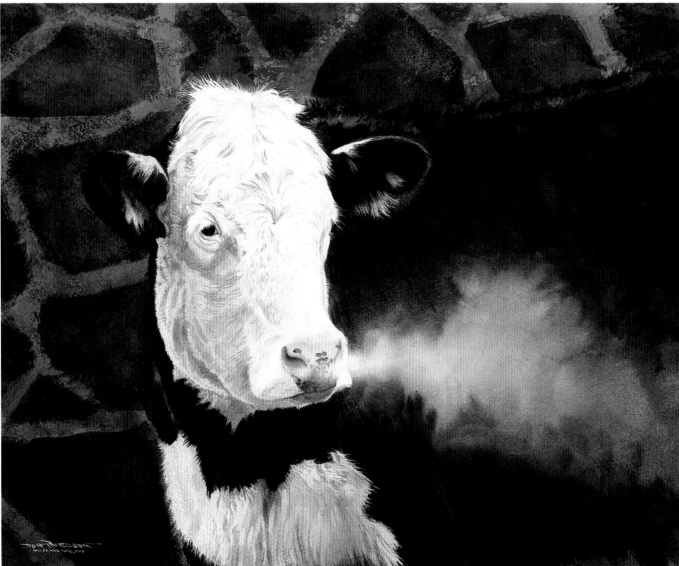

Replacing the existing background with a low-key stone wall kept all the focus on the cow, and her black coat made a perfect backdrop for showing off her breath in the frosty morning air. The concept also gave me a bonus—the title.

Frosty Morning
15½" x 19½" (39cm x 50cm)
Private collection

This is a technically acceptable reference photo with a basically sound composition, but there is nothing very special about its overall impact.

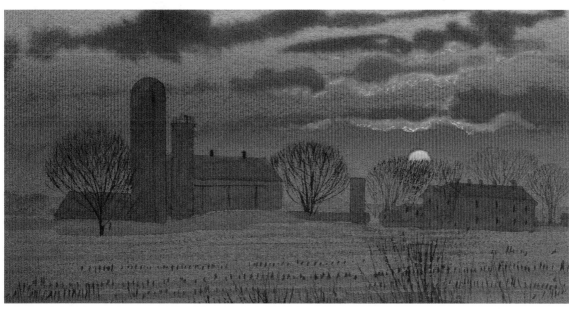

Look what a difference a deep sunset or a snowstorm can make to this typical rural scene. I cropped more of the foreground in the sunset version to further dramatize the sky.

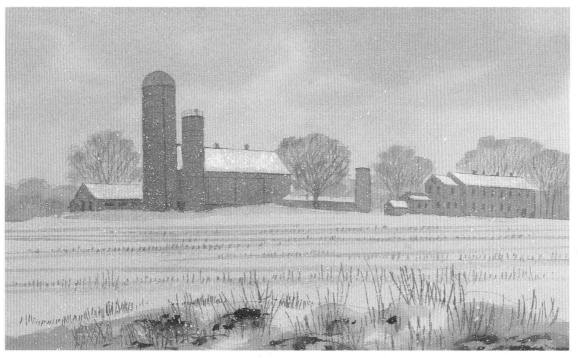

Finding Different Compositions in the Same Subject

Quite frequently the same subject will offer more than one composition, and I find myself trying to decide which one is best. But sometimes there is equal merit in all the compositions. My decision then is, "Which one to paint first?"

This kind of situation can happen in one of two ways. In the first, a single reference photo can be cropped suc-

cessfully more than one way, and in the second, you may find one or more equally good compositions with different views. It doesn't really matter which way this happens, except I prefer the second circumstance, because the paintings from different views will be very different from one another.

This lighthouse on Peggy's Cove, Nova Scotia, in this late afternoon sun offered something very special. I just happened to be there at the precise time when the sun was positioned perfectly for this view. By carefully moving sideways, I was able to center the setting sun directly on the edge of the lighthouse and create this wonderful point of interest.

The horizon line is below center in this composition. The lighthouse is just to the right of center, but at the same time, the sunburst is directly in the center for maximum impact. Usually the rule is to never center anything, but there is always the exception to every rule.

Lighthouse Point
18" x 28" (46cm x 71cm)
Collection of Patricia Cooke

As the sun sank lower in the sky, I found this view of the same lighthouse incredibly exciting, too. Notice how the sun just barely picks up the tops of the sea grass and turns it into a fiery orange color against the dark-colored rocks.

This sketch shows how the view shifted, making the horizon line above center for this composition.

Lighthouse Point 2
20½" x 29½" (52cm x 75cm)
Collection of Donald W. Patterson, Jr.

Building an Interesting Concept From Your Photo Library

In chapter four we saw how it is possible to build a painting from your photo library by selecting photos taken at different times and places (see pages 86, 87 and 94). The same is also true if you have a series of related photos.

You must train yourself to first concentrate on a concept and then figure out how to achieve it. Once you have a specific goal in mind, the rest follows naturally.

This sketch shows how a series of photographs can help build a composition. I used a combination of two geese in order to draw the main character. Always keep in mind, every composition needs a focal point. This is especially true if there are a number of similar components. I call this a "pecking order." No pun intended with the geese.

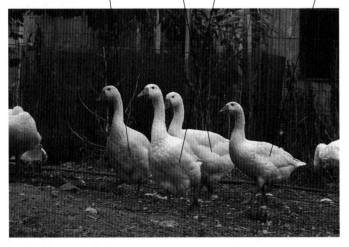
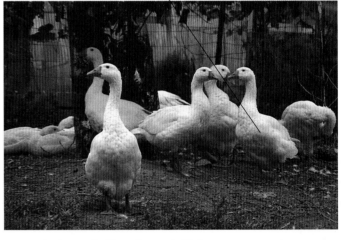

I selected these reference photos from a series of photos in my library. It bears mentioning again: There is no substitute for a camera when you are faced with a moving subject. Keep taking pictures until you are confident you have a broad enough selection to build a composition in the studio.

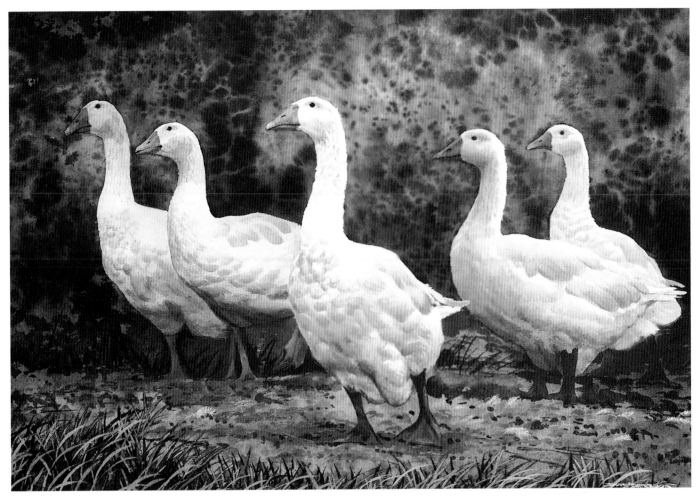

There is an anecdote attached to this painting's title. The painting was purchased as a gift for a man who actually was a chairman of the board, by one of his children. The moral is "Never underestimate the power of a title."

Chairman of the Board
17" x 25" (43cm x 64cm)
Private collection

The Importance of Texture

Texture plays an extremely important role in providing interest and information to your paintings. The great thing about texture is, it is not that difficult to paint, if you first carefully analyze the texture at hand and plan how best to handle it in a way that captures its essence without painting every nuance.

I had no idea these schoolchildren would be taking this short-cut at this precise time and location. My good fortune for this shot came from having my 300mm zoom lens at the right time.

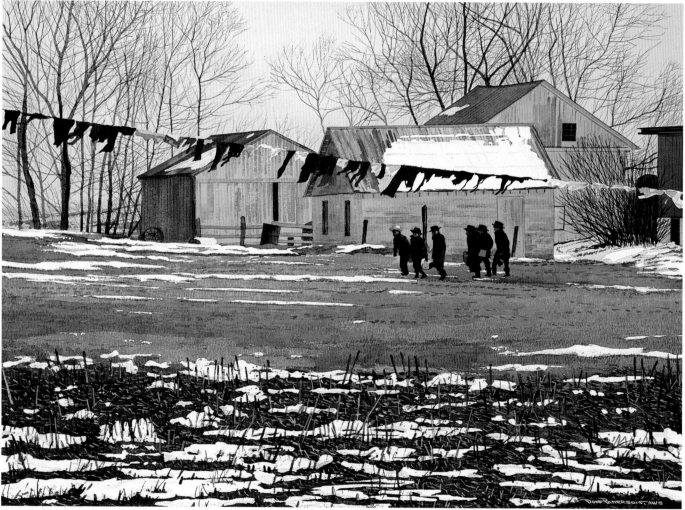

This painting has a strong narrative quality, and the foreground texture plays a particularly strong role with the cornstalks poking up through the patches of snow.

Short-Cut
19½" x 27½" (50cm x 70cm)
Courtesy of the Wild Goose Gallery

Painting Grass Texture

One of the most common textures we all face in painting landscapes is grass. I have developed my own method for painting this ubiquitous texture that may seem at first to be awfully involved, but I assure you, in principle, it is not.

Always remember, "Patience is a virtue," and to be sure, my grass painting method requires a considerable amount of it. But once you have mastered it, its application can be expanded to include anything that requires painting interlocking and/or overlapping fine lines such as reeds, weeds, straw and tree branches—a daunting task in transparent watercolor.

Paper
300-lb. (640gsm) Arches cold-press

Palette
WINSOR & NEWTON
Yellow Ochre
Raw Sienna
Zinc White gouache
Cadmium Yellow Pale gouache

M. GRAHAM & CO.
Sap Green
Permanent Green Light
Raw Umber
Payne's Gray
Burnt Sienna
Phthalocyanine Blue

Brushes
No. 2 round sable
No. 12 round sable
¾-inch (19mm) oval
2½-inch (64mm) flat latex

Other
1-inch (25mm) drafting tape
Winsor & Newton Art Masking Fluid
Paper towels
Ruling pen

STEP ONE:
Draw and Mask
Lightly pencil general directions of grass blades. Do not attempt to draw every blade. Use a ruling pen adjusted to 1mm thickness to apply masking fluid to those blades you want to be the lightest in color.

STEP TWO:
Begin With the Color
Apply separate washes of Yellow Ochre and Sap Green, using a 2½-inch (64mm) flat latex brush.

STEP THREE:
More Masking Fluid and Color
Continue to draw more grass blades with masking fluid. Apply richer color with a no. 12 round sable, first a mix of Raw Sienna and Yellow Ochre followed by a mix of Permanent Green Light and Sap Green using a wet-into-wet technique. When it's dry, draw more blades.

STEP FOUR: **Darker Color**

With a no. 12 round sable brush, wet entire surface. Add darker mixes of Raw Umber and Payne's Gray to selected areas using a ¾-inch (19mm) oval. When it's completely dry, draw more grass blades with masking fluid. By now you should be seeing only small negative areas between the grasses.

STEP FIVE: **The Darkest Color**

Add very dark mixes of Payne's Gray and Raw Umber to selected areas, using a ¾-inch (19mm) oval brush and a no. 2 round sable. When it's completely dry, remove all of the masking fluid with a rubber cement pickup. Make sure all of the masking is removed by lightly rubbing your hand over the surface.

STEP SIX: **The Finish**

Using a no. 12 round sable, apply a glaze of Sap Green over the whole surface. While it's still wet (an even sheen), use a ¾-inch (19mm) oval and add first a mix of Raw Umber and Payne's Gray followed separately with Burnt Sienna, Phthalocyanine Blue and Permanent Green Light to selected areas. With a no. 2 round sable, darken selected negative spaces with a mix of Raw Umber and Payne's Gray. Add highlights to grasses with a mix of Zinc White gouache, Permanent Green Light and Cadmium Yellow Pale gouache, using a no. 2 round sable.

Painting Wood Texture

A very common material to be found in landscapes is weathered wood, particularly if your subject preference is rural. Barns, houses, fences, etc., are all part of the rural scene. In the space allowed, I cannot possibly demonstrate every conceivable wood texture you can encounter in your forays into the countryside. Truthfully, I do not believe that is even necessary. The following demonstration will show you a basic approach to painting wooden boards commonly found in barns. You can change colors and lighting effects as desired, once you've learned the basic method.

Paper
300-lb. (640gsm) Arches
cold-press

Palette
WINSOR & NEWTON
Yellow Ochre

M. GRAHAM & CO.
Quinacridone Rose
Payne's Gray
Burnt Sienna
Raw Umber
Neutral Tint

Brushes
No. 4 round sable
No. 10 round sable
2½-inch (64mm) flat latex

Other
1-inch (25mm) drafting tape
Winsor & Newton Art Masking Fluid
½" × 4" (1cm × 10cm) strips of mat board
Paper towels

STEP ONE: The Drawing and Base Color
After making a pencil drawing defining the boards, use a 2½-inch (64mm) flat latex to apply three separate glazes in this order: 20 percent Yellow Ochre, 10 percent Quinacridone Rose and 10 percent Payne's Gray.

When dry, apply masking fluid to the open cracks in the boards. Use a wet-into-wet technique to apply washes of Payne's Gray, Burnt Sienna and Raw Umber.

STEP TWO: Dry and Wet Brush
Using a no. 10 round sable brush and Payne's Gray, Burnt Sienna and Raw Umber, paint variegated washes of dry-brush and wet-into-wet. Dragging over a wet color with a dampened paper towel is a good way to texturally blend a color into the background colors. Begin to define cracks with a very dark mix of Payne's Gray and Raw Umber.

STEP THREE: Added Texture
Using ½" × 4" (1cm x 10cm) strips of mat board with the ½" (1cm) end dipped in a mix of Payne's Gray and Raw Umber, tap on the horizontal and diagonal saw marks. The same strips can be used to drag texture vertically down the boards. With a no. 4 round sable, detail knotholes with a dark mix of Payne's Gray and Raw Umber. Remove mask.

STEP FOUR: Finishing
Add final details to the cracks, using a no. 4 round sable. Deepen color on right side with a wash of Neutral Tint and Raw Umber, using a no. 10 round sable.

Add Live Subjects to Appropriate Settings

Never underestimate the importance of putting life into your paintings when appropriate. I can't tell you how many times I have added live subjects to my paintings. They can be the essence of your paintings. Living subjects add interest and narrative information like nothing else will to your works. With a camera, living subjects can be captured and retained for future use when inspiration and/or necessity require it.

When you are out in the field make sure to think about settings for live subjects. Very often it is possible to find perfectly good settings that seem incomplete in themselves. Many times a small addition of life is all that is needed to complete the scene. Don't hesitate to record something that would make a perfect setting or backdrop for a live subject. This also can happen the other way around, where you find a great live subject in a poor setting. By all means, record the subject, because chances are, you may already have the perfect setting in your files or will find it at another time. This further points out the importance of filing your photos in a manner that facilitates finding what you need when you need it.

Add Life for a Sense of Scale
I was truly taken by this composition, but somehow I felt the need to add some life for a sense of scale. This is a very big barn, and with the addition of the pigs, I believe the barn's bigness is more realized.

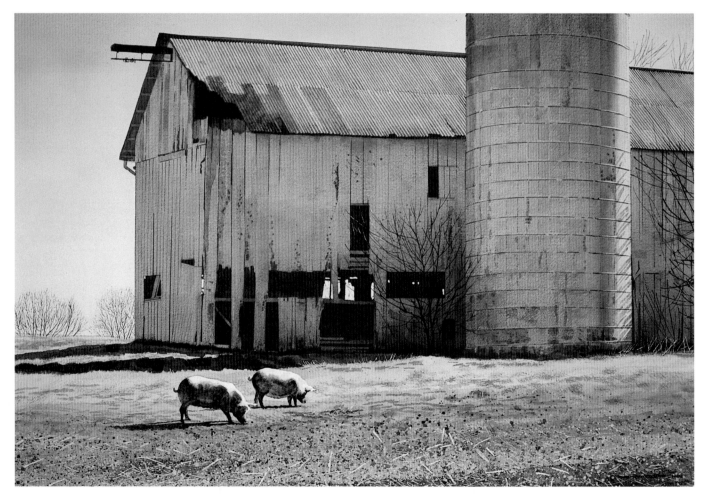

Slim Pickins
18½" x 27½" (47cm x 70cm)
Private collection

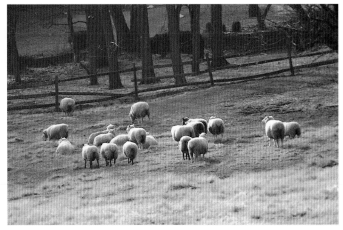

I loved this old barn in the Colonial Plantation section of the Ridley Creek State Park, Pennsylvania, but I felt the pasture needed some inhabitants.

Since they raise sheep on the plantation, I knew they would be appropriate to use. This sheep reference photo is from a location nearby.

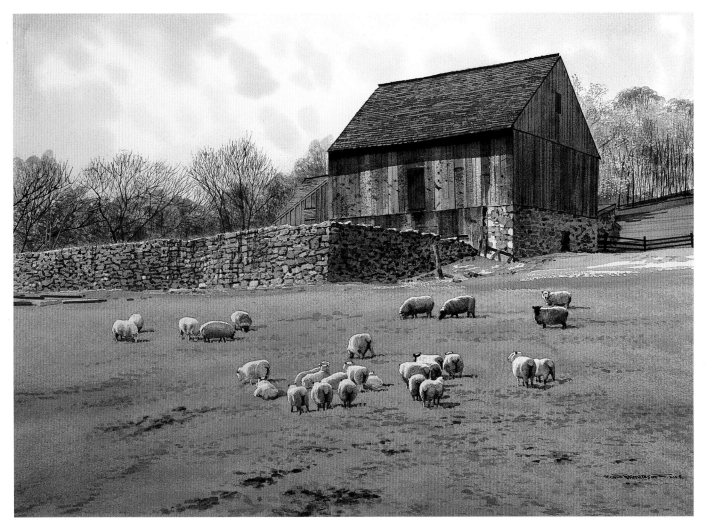

Colonial Plantation
18" x 26" (46cm x 66cm)
Collection of the artist

Conclusion

During the course of this book I have explained in great length how photographic equipment can play an important role in your pursuit of excellence, but beyond that, I have also emphasized it is you the artist that must prevail. If this message has been understood and accepted by you, the reader, I will feel this book has been truly worthwhile.

I also mentioned in the introduction I hoped this book would lead you in pursuit of your "truth," for it has always been my belief that every artist must at some point discover himself or herself and produce work that is their own singular statement. If you find this book is helpful in finding this truth, my mission is accomplished.

Roadside Ranch
20" x 27½" (51cm x 70cm)
Collection of the artist

Index